Marvels of Maiolica

Italian Renaissance Ceramics
from the Corcoran Gallery of Art Collection

JACQUELINE MARIE MUSACCHIO

BUNKER HILL PUBLISHING

in association with the

CORCORAN GALLERY OF ART

www.bunkerhillpublishing.com

First published in 2004 by Bunker Hill Publishing Inc.
26 Adams Street, Charlestown, MA 02129 USA

10 9 8 7 6 5 4 3 2 1

General Editor: Laura Coyle
Designer: Louise Millar
Copy-editor: Karen Palmer
Publication Consultant: Amy Pastan

Copyright © 2004 Corcoran Gallery of Art
Marvels of Maiolica in the William A. Clark Collection © 2004 Jacqueline Marie Musacchio

All rights reserved

Library of Congress Cataloguing in Publication Data
is available from the publisher's office

ISBN 1 59373 036 5

Printed in China by Jade Productions

The exhibition *Marvels of Maiolica: Italian Renaissance Ceramics from the Corcoran Gallery of Art Collection*
was made possible by a grant from the Scott Opler Foundation, Inc.
Guest Curator: Jacqueline Marie Musacchio
Corcoran Gallery of Art Curator: Laura Coyle
Corcoran Gallery of Art Manager of Special Exhibitions: Joan Oshinsky

Frances Lehman Loeb Art Center, Vassar College, Poughkeepsie, New York
April 9, 2004 – June 13, 2004

Museum of Fine Arts, St. Petersburg, Florida
September 25, 2004 – January 2, 2005

The Frick Art and Historical Center, Pittsburgh, Pennsylvania
January 22, 2005 – April 3, 2005

Frederik Meijer Gardens and Sculpture Park, Grand Rapids, Michigan
September 22, 2005 – January 1, 2006

The Hillstrom Museum of Art, Gustavus Adolphus College, St. Peter, Minnesota
February 6, 2006 - March 19, 2006

Taft Museum of Art, Cincinnati, Ohio
April 7, 2006 – June 18, 2006

Contents

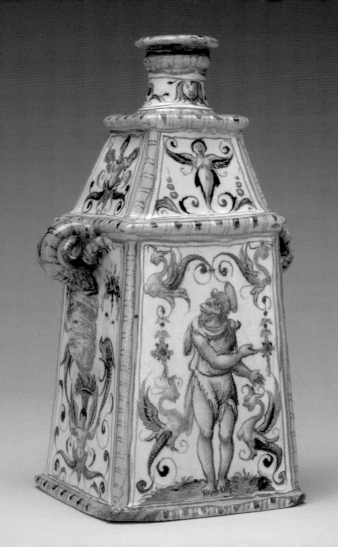

Foreword

Jacqueline Marie Musacchio's examination of Italian Renaissance ceramics—which focuses on the maiolica in the Corcoran's William A. Clark Collection—offers fresh and fascinating insights into just a few of the master works that belong to Washington's oldest art museum. The entire Clark Collection consists of more than eight hundred works that were donated to the Gallery in 1925 by copper-mining baron and former Montana senator, William A. Clark. Among the collection's treasures are Greek and Roman antiquities, near Eastern carpets, antique lace, late-nineteenth-century French paintings, and an elaborate eighteenth-century interior, the Salon Doré. Of course, the Corcoran is also renowned for its collection of nineteenth-century American paintings and sculpture, as well as for a broad selection of twentieth-century painting, sculpture, and photography. This book serves not only to illuminate the life and culture of a pivotal era—the Renaissance—but to introduce readers to some of our extraordinary, less well-known holdings.

As Professor Musacchio suggests, many parallels may be drawn between our society and that of Renaissance Italy. Surely we can identify with Renaissance figures such as the discriminating Isabella d'Este, the art historian and artist Giorgio Vasari, and the local apothecary, who surrounded themselves with the most exquisite utilitarian objects, demonstrating their love of beauty, their elevated taste, and their social status.

As a longtime enthusiast of contemporary Italian maiolica, I am enthralled by the compelling story of maiolica's integral role in the life of Renaissance Italy. Ceramics served many functions during that period. In addition to their utilitarian roles, they disseminated classical aesthetics and subjects to a wide audience. Through them we have a better understanding of long-ago domestic mores; while the individual objects help us to recognize the coats of arms of noble families, they also provide clues to the practice of medicine by the proprietor of the village apothecary.

Although we no longer look for ceramic ware in drugstores, many of us do go to great lengths to have it adorn and enhance our domestic lives. I was fortunate to reside in Italy for a number of years and enjoyed the chance to see and acquire maiolica from many different regions of the country. I was entranced, on my family's first trip to Grazia, the well-known contemporary maiolica factory in Deruta, by the show-

rooms filled with dinner services and domestic objects, from elevated fruit bowls and cream and sugar sets, to ashtrays and pitchers. Now I claim an elegant egg cup from Deruta (Umbria), a set of pasta dishes from Orvieto (Umbria), a decorative platter from San Gimignano (Tuscany), a plate from Gubbio (Umbria), and a group of antique tiles from Erice (Sicily) in my personal collection, all of which hold special significance depending on how or where my family acquired them.

In recent years, my family has focused its maiolica excursions on visits to a dealer in Deruta who specializes in the reproduction of Renaissance-era objects using traditional techniques. His models come primarily from prototypes preserved in Deruta's Museo della Ceramica. Now that we possess a few of those reproductions, we have enjoyed imagining even more vividly the lives and times of the civilization that first created them. With the Clark Collection maiolica at the center of attention, museum visitors need not contemplate modern reproductions. Instead, they have a new opportunity to appreciate the storied originals and the era they reflect.

Having amassed a multitude of plates, pitchers, butter dishes, vases, and tiles, I find that the maiolica not only marks significant periods in my life, but also reminds me through its exquisite craftsmanship that beauty and meaning are still to be found in objects that best symbolize family, conviviality, food, and domestic well-being. Professor Musacchio's thorough investigation of the context surrounding the Clark Collection maiolica testifies to the esteem and value attached to these pieces during the Renaissance. I would suggest that our appreciation of the original objects also extends in at least a small measure to their contemporary successors, which connect us to the past while enhancing our lives today.

Marvels of Maiolica marks the second major publication to treat this aspect of the Corcoran's Clark Collection. It builds on the 1986 catalogue, *Italian Renaissance Maiolica*, by Wendy M. Watson. I want to express my thanks to Professor Musacchio for her insightful text. The new publication has also greatly benefited from the expertise of Laura Coyle, the Corcoran's curator of European Art, who deserves our grateful thanks, not only for initiating this project, but also for her diligent work to bring this book to fruition.

Jacquelyn Days Serwer
Chief Curator
November, 2003

Acknowledgements

Just as in a Renaissance ceramics workshop, many gifted people at the Corcoran Gallery of Art have worked together to create a beautiful and useful product. For this book, my first thanks go to Jacqueline Marie Musacchio, assistant professor of art history at Vassar College, for her guest appearance in our studio. At every step of the intricate process of creating *Marvels of Maiolica*, her expertise, attention to detail, and good humor were essential. Next I would like to express my appreciation to Jacquelyn Days Serwer, chief curator at the Corcoran Gallery of Art, whose enthusiasm for Italian ceramics and this project were crucial. Also at the Corcoran, Joan Oshinsky, manager of traveling exhibitions, and Dare Hartwell, director of conservation, made it possible for us to share our important maiolica collection with lovers of Italian art around the country. Others at the Corcoran who also played important roles include Kelly Baker, Katherine T. Gibney, Lauren Harry, Dave Jung, Daniel Klein, Jung-Sil Lee, Deborah Mueller, Elizabeth Parr, Clyde Paton, Jan Rothschild, Robert Villaflor, and Nancy Swallow.

We also called on the talents of those outside the Corcoran. Amy Pastan, publications consultant, skillfully guided us through the editorial thickets, and Lee Ewing expertly photographed the Corcoran's ceramics. Ib Bellew, Carole Kitchel, Karen Palmer, and Louise Millar at Bunker Hill Publishing carefully managed the book's production. For their support in various ways, I also want to say thank you to Paul Daniel, Albert Marshall, Anthony J. Ratyna, Douglas Robertson, and Mariana Virginia Coyle Robertson.

As in the Renaissance, discerning patrons remain crucial for the most important cultural projects. For its generous financial support of *Marvels of Maiolica*, I want to thank The Scott Opler Foundation, Inc., under the direction of James N. Peebles. I am certain Scott would have loved this publication and exhibition.

Laura Coyle
Curator of European Art

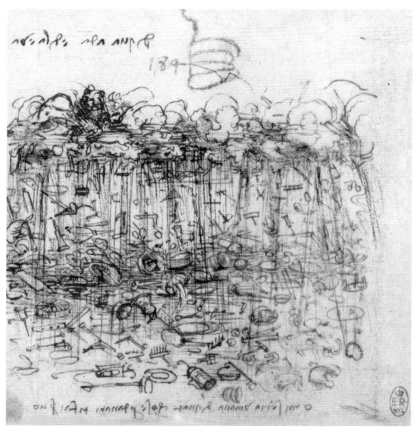

1. Leonardo da Vinci, Rain of Goods, *circa 1510 (Collection of Her Majesty Queen Elizabeth II, Windsor). Lamenting the materialism he observed around him, Leonardo wrote across the bottom of this drawing, "Oh human misery; how many things you must serve for money."*

Marvels of Maiolica
from the Corcoran's William A. Clark Collection

Jacqueline Marie Musacchio

In his treatise *On the Family* (*Della Famiglia*, 1430), the humanist Leon Battista Alberti noted that wealth, and its material trappings, showed both social and moral worth; they enabled the owner to do great deeds for himself, his family, and his community.[1] Alberti's trappings went far beyond painting, sculpture, and architecture to encompass a wide range of everyday objects, including the beautiful and functional tin-glazed earthenware now known as maiolica. Alberti's emphasis on what we would consider relatively modest goods is at odds with our standard perception of Renaissance Italy. Indeed, we usually think of Renaissance Italy as the society responsible for the monumental achievements of Botticelli, Michelangelo, and Leonardo da Vinci. But recent research reveals that, during this period, highly skilled artisans also produced an impressive array of beautiful, functional objects. Renaissance Italians, especially those in urban centers, spent a great deal of money furnishing their homes and workplaces. In fact, this period

has been characterized as an "Empire of Things."[2] It was a time when growing consumerism led to increased production, acquisition, and display of an immense variety of both modest and luxury items. As Alberti indicated, these possessions were enormously important to the family and its reputation in the larger community.

Contemporary inventories confirm this ever-multiplying array of goods in the increasingly sumptuous households of Renaissance Italy. A veritable deluge of them appears in a drawing by Leonardo da Vinci, where they cascade to the ground in a chaotic display (figure 1). Across the bottom of the folio, Leonardo wrote, "Oh human misery; how many things you must serve for money," reflecting on what he saw as the futility, and the cost, of such materialism.[3] It is ironic that the livelihoods of Leonardo's artist contemporaries depended as much upon the production and sale of these goods as they did upon the monumental art forms we traditionally study.

9

One of the types of objects Leonardo may have had in mind, as he lamented Renaissance materialism, were ceramics in general and maiolica in particular. Beginning in the early fifteenth century, a surprising variety and quantity of ceramics formed an important part of Renaissance life. Indeed, Italians were avid consumers of all types, local and imported, large and small, decorative and, most of all, utilitarian. Focusing on examples of Italian maiolica from the Corcoran Gallery of Art's William A. Clark Collection, we can illuminate the history and function of maiolica in the lives of Renaissance consumers.

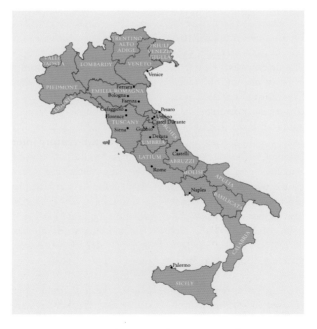

2. Map of Major Maiolica Centers in Italy

Ceramics in Renaissance Italy

Italians, and Europeans in general, had used earthenware since antiquity. These wares were made from clay, an easily manipulated material that can be either fired or air-dried. However, by the eleventh century, a refined version known as tin-glazed earthenware became popular throughout much of Europe. Although this process was used in antiquity, tin-glazing and its resulting opaque white surface coating was forgotten in the west until Islamic ceramists revived it in the eleventh century and spread their wares and their technique to the west. Almost immediately, these portable wares arrived in Italy; tin-glazed bowls ornamented building facades or served everyday household uses.[4] By the fourteenth century, Italian ceramists had mastered the method and began to produce wares in a notable variety of shapes and sizes. Artists, and in some cases whole towns, began to specialize in different styles of painting on the tin-glazed surfaces, and occasionally these places of manufacture were listed in inventories. This allows us to attribute, or at the very least localize, many pieces today (figure 2).[5]

Ceramists often used tin-glazing to imitate imported far eastern porcelain, with its distinctive blue designs on a white ground.

The beauty and rarity of eastern porcelains amazed covetous travelers like Marco Polo, whose thirteenth-century visit to China helped bring a wider awareness of porcelain to the Italian market. In fact, our word "porcelain" comes from Polo and his fellow Italians, who marveled at the technique and called it *porcellana*, for its resemblance to seashells of that name. True porcelain is made of different materials and fired at a higher temperature to create a white, hard, and thin body, but that technique did not come to Europe until the early eighteenth century.[6] This made porcelain, and even imitation porcelain, highly collectable. The Marchesa of Mantua, Isabella d'Este, was particularly distressed in 1527 when a "chest full of beautiful porcelain vases" disappeared as she fled the Sack of Rome. Her "porcelain" was certainly tin-glazed Italian wares, however; we know that she bought imitation porcelain from an Urbino workshop in 1510. Nonetheless, this cargo was the subject of a frantic letter-writing campaign on Isabella's part, as she asked various influential figures for assistance in its recovery. As a discerning patron with limited means, Isabella was particularly conscious of the power and status conferred by such prestigious items, and their disappearance dis-

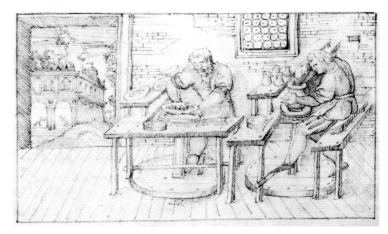

3. Cipriano Piccolpasso, Ceramists Shaping Wares, *circa 1557 (Victoria and Albert Museum, London). This charming drawing, from a manuscript on maiolica production, shows ceramists shaping clay by wheel, mold, and hand.*

tressed her enormously. Imitations like these, therefore, were treasured possessions among collectors like Isabella.[7]

We know a great deal about the production of tin-glazed earthenware because of a manuscript entitled *The Three Books of the Potters' Art* (*I tre libri dell'arte del vasaio,* circa 1557) by the Italian courtier Cipriano Piccolpasso.[8] The treatise was commissioned by the French cardinal François de Tournon, likely as a handbook for ceramists in his native country; it was never printed, and exists only as a handwritten and illustrated

copy now in the Victoria and Albert Museum in London. It provides a wealth of information, although Piccolpasso admitted that he could not learn everything he needed to know because of the great secrecy surrounding certain aspects of this very competitive trade. It is clear, however, that the technique was a complicated multi-step process. First, the clay was collected, strained, and dried to a plastic consistency. Then it was shaped into the desired wares, by wheel, mold, or hand (figure 3), and fired in a kiln. When it had cooled, the ceramist coated the porous vessel

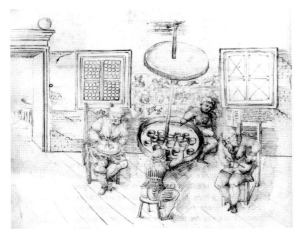

4. *Cipriano Piccolpasso,* Ceramists Painting Wares, *circa 1557 (Victoria and Albert Museum, London). The prints and drawings hanging on the wall of the studio helped ceramists create their compositions.*

with a glaze made primarily of tin and lead oxides. The vessel absorbed this glaze immediately, leaving a powdery white coating on the surface. Then it was painted, using pigments made from ground metals suspended in water. The most common pigments were made from metallic oxides: copper made green, iron made orange, manganese made purple, cobalt made blue, antimony made yellow, and, of course, tin made white. The clay immediately absorbed the water in the paint, leaving the pigments on the surface. Once the brush touched the vessel, and the water was absorbed into the clay, it was almost impossible to correct any errors or change the composition. The precision this required could be daunting, and ceramists worked from modelbooks or contemporary prints to help overcome this difficulty (figure 4). Furthermore, the pigments did not appear in their true colors until they were fired, so at this stage it could be difficult to get an accurate sense of the finished product. The technical skill needed to paint on these wares, which were often made in complex shapes, inspired great pride, and some ceramists signed their vessels with their names, initials, workshop, or city, at a time when relatively few painters and sculptors did the same (figure 5). When painting was completed, some vessels were coated with a shiny lead glaze, and then all were fired again, at a slightly

13

5. Urbino, Francesco Xanto Avelli da Rovigo, Plate with The Sinking of the Fleet of Seleucus *(back), 1532 (Corcoran Gallery of Art, Washington, D.C.). Xanto proudly signed, dated, and inscribed his work, identifying the source as Marcus Junianus Justinus's third-century* History of the World, *Book 27.*

lower temperature. The wares remain so brilliantly colored today because the second firing fuses the colors to the vessels; we consequently see them as their original viewers did.

By the thirteenth century, ceramists in the area of Valencia in southern Spain had perfected an additional step in this process,

the application of iridescent metallic oxides known as luster. This too copied eastern innovations, in this case those of Persian ceramists.[9] After the second firing the ceramist painted on highlights, inscriptions, or whole blocks of color using compounds made from silver or copper oxides. Then the vessel was fired a third time, at even lower temperatures, using smoky wood to reduce the amount of oxygen in the kiln. This released a film of iridescent metal on the vessel's surface, and, after careful cleaning, it literally glowed with luster.

A great number of these Valencian lusterwares were imported to the Italian peninsula via the pre-existing trade routes through the island of Majorca (known today more commonly as Mallorca), to the east of the Spanish mainland.[10] Indeed, their stopover in Majorca may be one reason these ceramics acquired the name maiolica, a variation on the Italian word for the island itself. On the other hand, the name may come from the Spanish *obra de Mallequa*, or Malaga wares, in reference to the city on the southern Spanish coast where they were produced in large numbers.[11] Roman custom registers from the fifteenth century,

(opposite) 6. Deruta, Molded Dish with Judith and the Head of Holofernes, *circa 1525-30 (Corcoran Gallery of Art, Washington, D.C.). Ceramists in Deruta and Gubbio were renowned for their mastery of the difficult lusterware technique.*

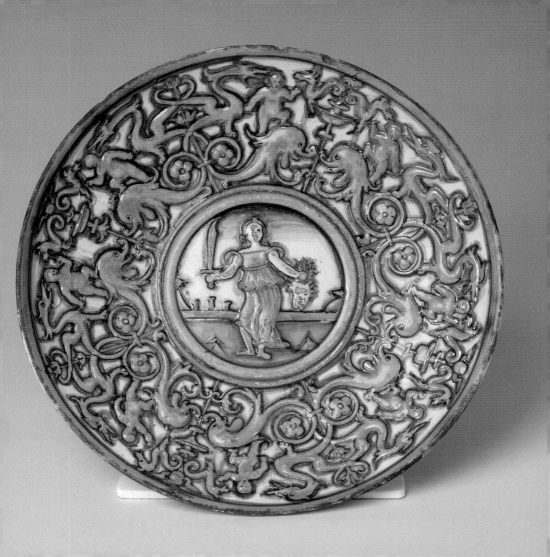

which detail the goods brought into the city and the duties paid for them, reveal that lusterwares came by ship from Spain, packed in jars, often in great quantities. Prominent Italian families commissioned these wares, embellished with their heraldry, directly from foreign shops. Other pieces were more generic, made with no particular buyer in mind. The steady supply of imported lusterwares must have kept prices reasonable, because even modest homes had occasional pieces in different shapes and sizes.[12]

The influx of these lusterwares generated interest in the process and ceramists in several central Italian towns were able to produce it by the late fifteenth century. The success rate was low; Piccolpasso estimated (certainly with some exaggeration) that only six percent emerged from this third firing intact. Certain ceramists became specialists in the technique, adding luster to both their own wares and those of others who sent them for this final treatment. The Umbrian towns of Deruta and Gubbio were especially famous for their lusterware (figure 6). Gubbio's prominence was due to the presence of Maestro Giorgio Andreoli, whose work was so esteemed that he received a special privilege from Pope Leo X.[13]

Because of their similarly rich finish, Italian lusterwares were also called maiolica.

In Leandro Alberti's discussion of the ceramics made in the town of Deruta in his popular geographical survey *Description of All of Italy* (*Descrittione di tutta Italia*, 1550), he stated that, "These vessels are called vessels of Magiorica, because this art was found first on the island of Magiorica [sic] and brought here."[14] Alberti further observed that the wares appeared gilded; this was appropriate, because lusterwares became a less expensive substitute for silver- and gold-plated vessels, usually referred to today as plate. Many families displayed plate on sideboards, or *credenze*, for important occasions, although some had to borrow it from relatives or friends to keep up appearances.[15] The cost made it difficult to acquire in significant quantities, but plate was a good investment and could be liquidated to its metal content when necessary. For considerably less money, however, some collectors bought lusterwares, and their display made almost the same visual impact as one of plate, even if, in financial terms, they were not as impressive.

Ceramics of all types attracted interested buyers, resulting in a highly successful industry.[16] With this came a further loosening of terminology; eventually all Italian tin-glazed earthenware, whether lustered or not, was referred to as maiolica, the term still used today.

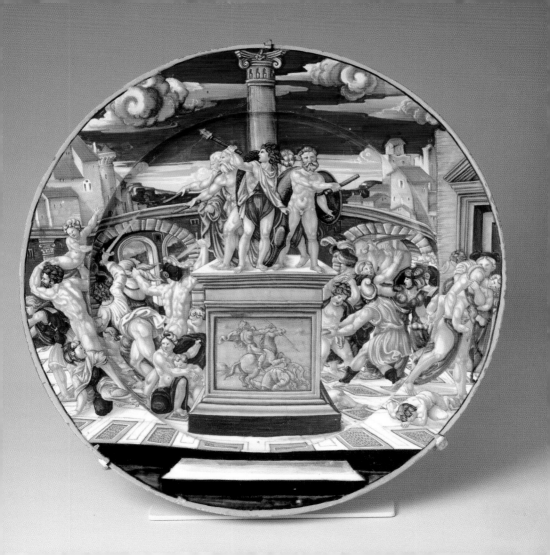

Ornamentation and Desirability

In addition to their more reasonable prices, ceramics had another advantage over plate, because they could show elaborate narrative scenes with greater clarity. Like the paintings that covered walls and furniture during this period, the ideal object was not only beautiful but also didactic, telling edifying or moralizing stories that reflected, or exaggerated, the owner's education, wealth, and social standing.[17] To accommodate this didactic role, *istoriato*, or historiated, ceramics developed in the late fifteenth century. These wares were painted with narrative scenes from classical history or literature, and their compositions were often based on contemporary prints.[18] Francesco Xanto Avelli da Rovigo, known as Xanto, one of the most inventive ceramists of his time, was especially adept at combining details from popular prints to create new compositions. His large plate depicting *The Massacre of the Innocents* is based on at least four prints from artists in Raphael's circle (figure 7), while another plate, with *The Battle of Roncevaux*, is based on perhaps six such prints (figure 8).[19] One of Xanto's favorite sources was the scandalous engravings by Marcantonio Raimondi, after designs by Giulio Romano, known as *I Modi*, which show couples in a variety of sexual positions (figure 9). The papacy censored these prints for licentiousness; most were destroyed, and Raimondi was jailed. But they were popular, and Xanto's compositional inventiveness is clear in his transformation of the suggestively posed figures in these prints to the heroes and heroines on his plates.[20]

Shortly after the mid-sixteenth century, *istoriato* scenes like these were complemented around the ware's rim or exterior by fanciful designs that came to be known as *grottesche*, or grotesques; in their most advanced stage, *grottesche* took up most of the surface area. The word derives from the rediscovery of the Golden House of Nero in Rome in 1480; its many underground chambers, or *grotte,* were painted with these elaborate, whimsical motifs, and the word stuck.

(previous page) 7. Urbino, Francesco Xanto Avelli da Rovigo, Plate with The Massacre of the Innocents, circa 1527-30 (Corcoran Gallery of Art, Washington, D.C.). Xanto based his composition for this plate, and the one in figure 8, on several different prints by artists in Raphael's circle.

(opposite) 8. Urbino, Francesco Xanto Avelli da Rovigo, Plate with The Battle of Roncevaux, 1533 (Corcoran Gallery of Art, Washington, D.C.).

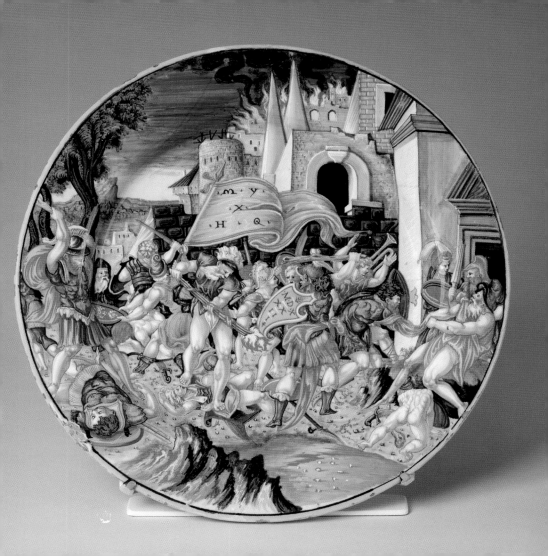

The Golden House paintings had immediate cachet because they were among the only surviving ancient paintings, and artists and patrons were keen to incorporate their designs into contemporary art. Raphael's use of *grottesche* in his paintings for the Vatican Loggie (circa 1519) made them especially popular, and this popularity soon found an excellent outlet in ceramic production. The Fontana and Patanazzi family workshops in Urbino were particularly adept at painting these fantastic motifs, as exemplified by the Corcoran's complexly painted ewer basin from the late sixteenth century (figures 10a and 10b).[21]

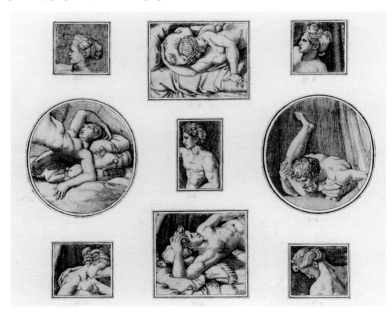

9. *Marcantonio Raimondi after Giulio Romano,* Fragments of I Modi, *1527 (British Museum, London). Erotic prints like these were censored by the papacy, but they remained popular sources for maiolica designs.*

10a. Urbino, Fontana Workshop, Ewer Basin with Europa and the Bull *(front), circa 1565-75 (Corcoran Gallery of Art, Washington, D.C.). The fanciful ornament on the front and back of this ewer basin, known as* grottesche, *was inspired by ancient Roman wall paintings.*

10b. Urbino, Fontana Workshop, Ewer Basin with Cadmus and the Dragon *(back), circa 1565-75 (Corcoran Gallery of Art, Washington, D.C.).*

The great quantity and diversity of surviving maiolica reveals that it was used by all segments of the population. Unlike some of the materials used to make paintings, sculpture, metalwork, jewelry, or textiles, the necessary raw material to make maiolica—clay—was inexpensive and plentiful. This of course had an impact on pricing. According to one estimate, 200 pieces of *istoriato* could be bought for the same price as one silver salt. In another case, an entire service of 84 assorted pieces cost only the equivalent of three to four months of unskilled labor.[22] Many pieces have heraldry that has not been identified, indicating that the patrons were not among the most historically or economically prominent families of their time. Maiolica with heraldry certainly was commissioned, but ceramists also made works for the open market in a range of prices. We know that some makers sold their wares to attendees at local fairs and festivals, which

attracted visitors from all social classes.[23] The occasional piece or two was well within the price range of most citizens; maiolica was available in prices to meet every budget.

At the same time, maiolica was very popular with elite collectors at the highest levels of society. We know of maiolica with the heraldry of the Este of Ferrara, the Farnese of Rome, and the Medici of Florence (figure 11), to name only a few.[24] In fact, heraldic maiolica was a suitable gift for a prince: an appreciative letter from Lorenzo de'Medici of Florence to a member of the Malatesta family of Rimini reveals that Lorenzo valued their gift of maiolica decorated with the presenter's arms "as if they were silver, because of their excellence and rarity... and because they are a novelty to us here."[25] Although he undoubtedly exaggerated his pleasure to flatter the Malatesta, Lorenzo had an obvious taste for maiolica; his own estate inventory of 1492 included a wide variety of it.[26] So it was not the price—whether high or low—that made maiolica so desirable. Instead, the technical skill it took to create it, edifying or entertaining iconography, and inherent functionality were what made maiolica both distinctive and popular for Renaissance patrons.

It was also important for Renaissance buyers to feel as if they had acquired something unusual and new. In his book *Lives of the Most Excellent Painters, Sculptors, and Architects* (*Le vite de'più eccellenti pittori, scultori ed architettori*, 1550 and 1568), often described as the first art history text of the Renaissance, Giorgio Vasari noted that, "As far as we can tell, the Romans were not aware of this type of painting on pottery. The vessels from those days, found filled with the ashes of their dead, are covered with figures incised and washed in with one color in any given area, sometimes in black, red, or white, but never with the brilliance of glaze or the charm and variety of painting seen in our day."[27] He knew about ancient wares because his hometown of Arezzo was a center for Roman ceramics; considering the premium he and his peers attached to the arts of classical antiquity, Vasari's claim that contemporary maiolica exceeded ancient ceramics was not made lightly.[28] It should be noted, however, that he also had a personal connection to the industry. Vasari's grandfather was a ceramist, and his profession gave the family their surname; in Italian *vasaio* means potter.

(opposite) 11. Tuscany, Probably Cafaggiolo, Footed Dish with the Arms of the Medici, *circa 1513-21 (Corcoran Gallery of Art, Washington, D.C.). This dish is associated with Giovanni de'Medici, who was elected Pope Leo X in 1513; the papal tiara and crossed keys of Saint Peter were added to his coat of arms at that time.*

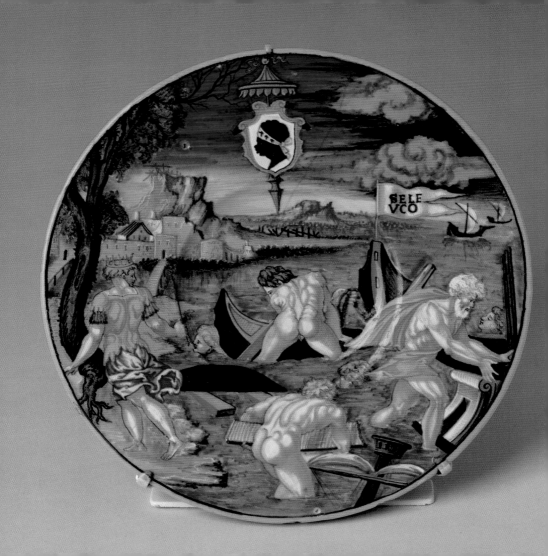

Function and Form

Many families ordered heraldic maiolica in extensive services of differently shaped wares to accommodate a multitude of diners and culinary needs. Documentary references to maiolica services frequently list pieces in multiples of twelve, implying that a dozen was the typical, and expected, number in a service.[29] One of the largest surviving services was painted by Francesco Xanto Avelli da Rovigo for the Pucci family of Florence in 1532; thirty-seven pieces can be identified by their use of the heraldic Moor's profile, including one at the Corcoran with *The Sinking of Seleucus's Fleet* (figure 12).[30] Eleven pieces survive from a service made by Nicola da Urbino for the Calini family of Brescia in the late 1520s, including one of the Corcoran's most impressive pieces, a dish painted with *The Muse Calliope Crowning a Youth* (figure 13).[31] The Corcoran also has a jar painted with the arms of Duke Guidobaldo da Montefeltro of Urbino on one side, and Judith with the head of Holofernes on the other (figures 14a and 14b).[32] Heraldic maiolica was popular outside of Italy, too, where it was presented as diplomatic gifts or purchased through Italian business contacts. The Corcoran has a plate from a service made in Urbino for the Nuremburg humanist Johann Neudörffer; his name and arms, as well as the composition, were copied from a print by the German etcher Hans Sebald Lautensack, which Neudörffer must have provided to the ceramist as a model (figure 15).[33] Models were especially important for foreign commissions, because Italian ceramists could not be expected to know the language, ornament, and heraldry used elsewhere.

From the evidence of services like these, it is clear that maiolica in the shape of tableware could, quite literally, be used at table. Recent research strongly emphasizes the inherent functionality of maiolica; indeed, it is the best explanation for the large quantities kept in many Renaissance homes.[34] In 1427, the Florentine Albizo del Toso stored 72 maiolica plates and bowls in his bedroom, probably in one or more of the room's ten chests.[35] Modern notions of privacy make it hard for us to appreciate the importance of this location; the bedroom often served as a combination study, living room, meeting hall, and dining area, depending on

(opposite) 12. Urbino, Francesco Xanto Avelli da Rovigo, Plate with The Sinking of the Fleet of Seleucus, 1532 (Corcoran Gallery of Art, Washington, D.C.). The heraldic Moor's head at the top of the composition identifies this plate as one from a service commissioned by the Pucci family of Florence.

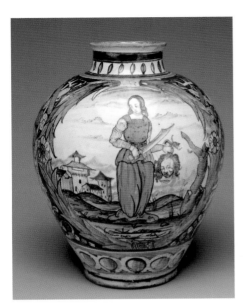

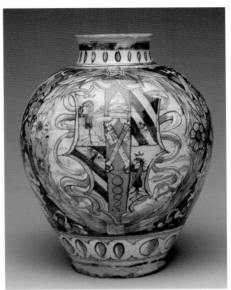

14a. Castel Durante or Urbino, Vase (front), *circa 1502-08 (Corcoran Gallery of Art, Washington, D.C.). One side of this vase shows Judith with the head of Holofernes.*

14b. Castel Durante or Urbino, Vase (back), *circa 1502-08 (Corcoran Gallery of Art, Washington, D.C.). This side of the vase is decorated with the arms of Guidobaldo da Montefeltro of Urbino in his role as Gonfalonier of the Holy Roman Church.*

circumstances, and it was where the most important possessions were kept. With storage space at a premium—there were no closets in Renaissance homes—Albizo would have had so many wares at hand only if he used them regularly. Yet in the past it was thought that maiolica showed too few signs of wear to have been used. This has been dis-

(opposite) 13. Urbino, Nicola da Urbino, Plate with Calliope Crowning a Youth, *1525-28 (Corcoran Gallery of Art, Washington, D.C.). This plate belonged to a service made for the Calini family of Brescia in the late 1520s.*

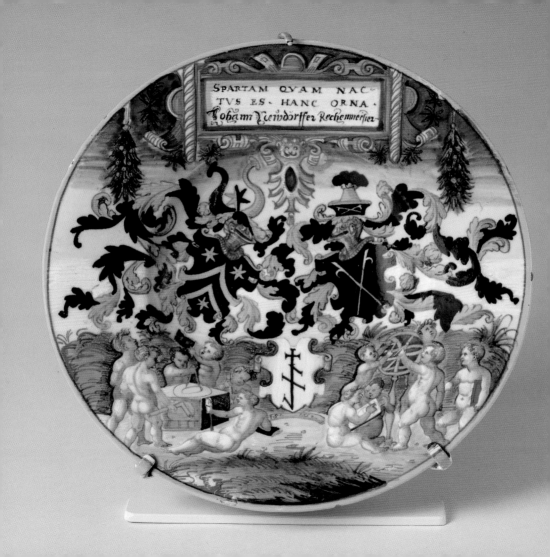

proven with a better understanding of dining habits. Individual metal forks and knives only came to Italy in the fourteenth century, from Byzantium, and they were not widespread until several centuries later.[36] In fact, forks appear only rarely in Renaissance inventories, and in many cases they were only for ceremonial use. In 1492, Lorenzo de'Medici's several dozen forks were scattered throughout his home, not located in one place for ease in serving and setting a table.[37] And eating with one's hands, or using a piece of bread as a scoop, left no mark on shiny maiolica surfaces, accounting for their lack of visible wear.

Changes in Renaissance social life, and in culinary and banqueting habits, had a great impact on maiolica. The demographic disaster brought on by the Black Death of 1348, and its frequent recurrences in the ensuing centuries, resulted in the death of anywhere from one-half to two-thirds of the population of Europe; Italian urban centers were among the hardest hit.[38] There were some positive repercussions, however. Increased wages and wealth divided among a smaller number of people enabled the purchase of goods beyond the mere necessities

of life. Farmers no longer had to focus on providing only the most essential foods to a burgeoning population, so they diversified their crops. Imports from the New World further changed dietary habits. Both the ingredients and the preparation of food and drink became more varied. New forms of consumption required new wares for serving, eating, and entertaining. A more complex array of serving pieces is reflected in contemporary cookbooks, where a wide range of terms describe the vessels each recipe required.[39] Maiolica adapted to all of these changes exceedingly well.

One of the most popular types of maiolica was simply tin-glazed, or white, in imitation of porcelain. Few pieces survive today, because of its popularity and functionality, as well as its relatively low cost; it must have been used until it was broken and then it was discarded. The Florentine Bernardo Bini had four white maiolica spice bowls in his kitchen, certainly filled with ingredients used every day in the preparation of his family's meals.[40] The increasing availability of spices from exotic locales, as well as the basic need for salt in this prerefrigeration era, made spice containers

(opposite) 15. Urbino, Plate with a Heraldic Design, 1552-63 (Corcoran Gallery of Art, Washington, D.C.). Commissions for Italian maiolica sometimes came from abroad; this plate was made for the Neudörffer family of Nuremburg.

29

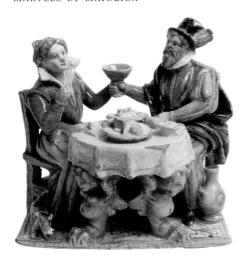

16. Urbino, Fontana Workshop, Dining Couple from
an Inkstand, *sixteenth century (Museo Civico, Pesaro).*

maiolica were also important. In 1524,
Felice della Rovere, the illegitimate daughter
of Pope Julius II, received a shipment of
white maiolica at her castle at Vicovaro, near
Rome. Vicovaro was well removed from the
social whirl of the papal city; her children
resided there and she visited on occasion, so
there was no need for elaborate tableware.
Furthermore, this shipment contained an
irregular number of wares: eighteen round
plates, eleven bowls, two large plates, two
medium plates, two candleholders, one jug,

and one salt.[42] The diverse numbers indicate
it was not a complete service; perhaps Felice
had requested pieces to replace those broken
earlier by her young children.

But simple white maiolica was not the
only kind used at table. A maiolica statuette
of a dining couple, made in Faenza around
1600, is particularly revealing in this regard
(figure 16). The couple eat off of white
maiolica painted with an orange pattern,
the design visible even on this small scale.
To date, however, no contemporary painting
evidence is known for the use of either
grottesche or *istoriato* maiolica for dining. In
fact, the most evocative representation
comes from the mid-nineteenth century; it
is John Everett Millais's painting *Lorenzo and
Isabella,* based on Boccaccio's *Decameron*
(IV:5), which shows a banquet served on *isto-
riato* (figure 17). As a founding member of
the Pre-Raphaelite movement, Millais was
concerned with historical veracity, and the
details of his composition demonstrate
careful attention to what he knew of six-
teenth-century costume and furnishings.[43]

Both documentary and physical evidence
give some validity to Millais's representation.
For example, in 1528, an agent for the Duke
of Urbino, at the court of Pope Clement VII,
described how he saw the Pope eating off of
earthenware painted with a simple white-on-

white ornament. The agent asked the Pope's steward why Clement "didn't eat from ware painted with figures. I got the answer that he ate off nothing else, reserving the other kind for the use of cardinals."[44] Clement preferred more subdued design while dining alone; considering his extravagant patronage of Benvenuto Cellini and Michelangelo Buonarroti, this pretense of apostolic poverty is somewhat surprising. Apparently, however, when Clement ate with his cardinals, they all enjoyed dining with the more ostentatious *istoriato*. In fact, *istoriato* wares seemed to have had particular favor in the papal court. The earliest evidence for an *isto-*

riato service from Urbino was commissioned by Cardinal Ludovico Podocataro in 1501; the contract calls for an impressive assortment of different wares, painted with carefully detailed iconography.[45]

Elaborately painted maiolica also graced less formal settings. It was considered especially appropriate for informal gatherings in countryside villas, where the privileged retreated from their urban homes. Indeed, an early-seventeenth-century book on country living noted that it was proper to have maiolica in your villa as a sign of good breeding.[46] Several prominent patrons followed this advice. In 1518, Clarice Strozzi paid a Montelupo potter for an 84-piece service painted in the porcelain style, with the Strozzi arms, for her villa Le Selve outside of Florence. In 1524, Isabella d'Este's daughter sent Isabella an *istoriato* service by Nicola da Urbino, noting when she did so that maiolica was a "cosa da villa," or "villa thing" and that she hoped Isabella would use it at her country property in Porto.[47]

Further evidence for use comes from maiolica itself. Although much is fashioned as plates or bowls, there were also flasks, vases, salts, ewers, and candleholders, as well as differently edged, fluted, concave, and convex vessels in infinitely complicated shapes, all of which would have been diffi-

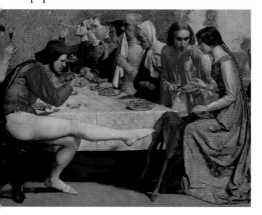

17. John Everett Millais, Lorenzo and Isabella, *1849 (Walker Art Gallery, Liverpool).*

cult to form, fire, and paint. There would be no need for this proliferation of forms unless each was required for a particular activity. Very few maiolica wares are so outlandish that we cannot conceive of their use. Partly because of the limitations of the clay,

18. Urbino, Fontana Workshop, Pilgrim Flask, *circa 1570-80 (Corcoran Gallery of Art, Washington, D.C.). The shape of this ornate flask is based on the hollow gourds used to carry water by travelers on pilgrimages.*

Italian maiolica is not as fantastical as some contemporary Venetian glassware, or later Sèvres and Meissen porcelain, most of which was also put to use.[48] And as habits changed, forms changed. In 1530, an agent for Federico Gonzaga reported on his attempts to procure *istoriato* for the Marquis; after describing what he could acquire, he noted, "because these large dishes are not used any more I would like to omit them."[49] Either whatever the dishes were meant to hold, or this manner of serving, had become unfashionable, so the agent saw no need to buy them any more.

Documents sometimes state exactly how a particular piece of maiolica was used. This is fortuitous, because certain distinctions would be impossible to establish with only the maiolica as evidence. For example, in 1569, the Venetian courtesan Julia Lombardo had a white maiolica pitcher for washing her hands. In 1583, the Florentine Jacopo Salviati had twelve Faentine maiolica plates for serving peacocks and turkeys, eighteen for hare and goats, and thirty for capons and pheasants; he also had sixty more for soups and stews, and eighteen for sauces. In 1587, Antonio de'Medici had eight *istoriato* fruit bowls from Urbino. In 1590, Cammillo Gonzaga had forty-eight Faentine plates, half for salad and half for

olives. And in 1609, the Urbino Ducal family had an *istoriato* basin for shaving.[50]

A maiolica jug made in Faenza for the Salviati family of Florence in 1531 is painted with the word "ollio," or "oil," but this is unusual; most maiolica was not so conveniently inscribed.[51] Occasionally we can guess function from the shape. A large *istoriato* platter made by Guido Durantino's workshop for Cardinal Duprat in 1535 has a spout, cleverly concealed in the painted river, to drain the food served on it.[52] A large, late-sixteenth-century shallow basin from the Fontana workshop in Urbino has finely painted *grottesche* around a raised boss (figure 10a).[53] This boss would have secured the foot of a now-lost ewer, and the two wares together would have been used for ceremonial handwashing. As we noted earlier, most people ate with their hands, rather than with utensils, so cleanliness was important. In fact, in his treatise *On Good Manners for Boys* (*De Civilitate Morum Puerilium*, 1530), the humanist Desiderius Erasmus noted that one should "Never sit down without having washed and without first trimming your nails lest any dirt stick to them."[54] The iconography of this basin, from Ovid's *Metamorphosis*, even depends on a water theme: on the front (figure 10a), the boss shows Europa carried across the sea by Jupiter in the guise of a bull, and on the reverse (figure 10b), her brother Cadmus slays the dragon guarding the spring where he founds Thebes.[55]

Other pieces, however, simply adopted the shapes customarily associated with particular functions. This was the case with maiolica pilgrim flasks. The Corcoran flask, from the Fontana workshop, is painted with the Ovidian story of Myrrha; one side shows her incestuous relationship with her father, Cinyras (figure 18), and the other the death of their son, Adonis.[56] Flasks of this shape were originally made from lightweight, hollowed-out gourds, and used by pilgrims and other travelers to carry water on long journeys. The loops on the side of this flask, and the holes on the base, derive from this practice; on the flasks made from gourds, they guided cords that allowed them to be carried upright around the travelers' neck .. A maiolica flask, however, would be too heavy, and too fragile, to wear.[57] Instead, this flask might have been used to serve a beverage at table, where its provocative iconography could be appreciated and perhaps debated.

Large lustered display plates, or *piatti da pompa*, from the town of Deruta adopted functional shapes but served decorative purposes. An example at the Corcoran is paint-

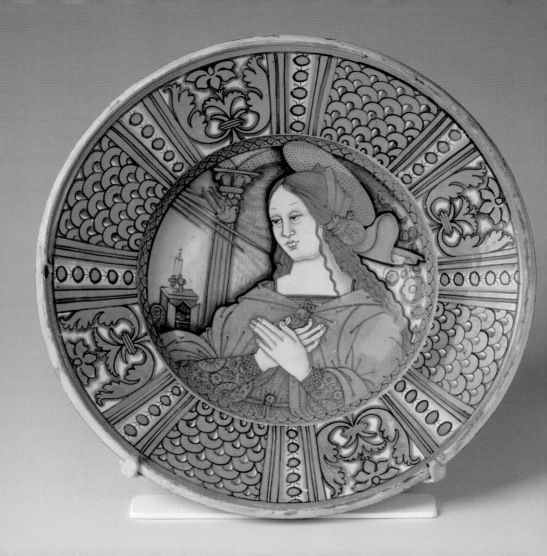

ed with a half-length Virgin of the Incarnation (figure 19).[58] The two holes in the footring on the reverse of the plate were punched during production, with the expectation that the plate would hang on a wall rather than serve as tableware. The surviving numbers of display plates, and the repeated depiction of strikingly similar figural types on each one, may be the result of a mass production of sorts; cartoons or prints after the work of painters like Perugino or Pinturicchio may have been used as models, so consumers could buy fashionable plates that looked just like the ones their friends and relatives owned.[59]

Another Corcoran display plate is painted with an ass attacking a wolf (figure 20).[60] This unusual scene is explained by the scroll that twists around the animals; in an abbreviated vernacular, the inscription translates, "See, people, to what the world has come when the ass, if he wants to, can eat the wolf." This may have been a provocative proverb, or a statement on contemporary society; it demonstrated the carnivalesque "world upside down" theme popular at that time, where things were not as they should be. In this case, the inscription was sure to encour-

age discussion among its educated, socially savvy viewers. Recent research indicates that maiolica with such inscriptions could be evidence for the value placed on sociability in Renaissance society.[61] A display of plates with provocative texts might stimulate conversation among nearby diners, prompting an entertaining and lively banquet with no conversational lulls. The idea of conviviality, expounded by the fifteenth-century Naeopolitan humanist Giovanni Pontano, was important in this context. Pontano's emphasis on companionship while dining would have been assisted by plates with these provocative speaking scrolls.[62] Different plates may have been used for different company, as the host determined the most appropriate display for his or her guests.

Although there were a significant number of maiolica wares with these speaking scrolls, many of which may refer to Renaissance social mores, there were far fewer pieces illustrated with contemporary or near-contemporary events. Recognizable historical scenes were not popular; judging from surviving wares, patrons preferred classical, biblical, or fantastic imagery, although Xanto was known to include commentaries

(opposite) 19. Deruta, Dish with the Incarnation of the Virgin, circa 1520-25 (Corcoran Gallery of Art, Washington, D.C.). Holes in the footring of this fine lusterware dish indicate it was always intended as a piatto da pompa, or display plate.

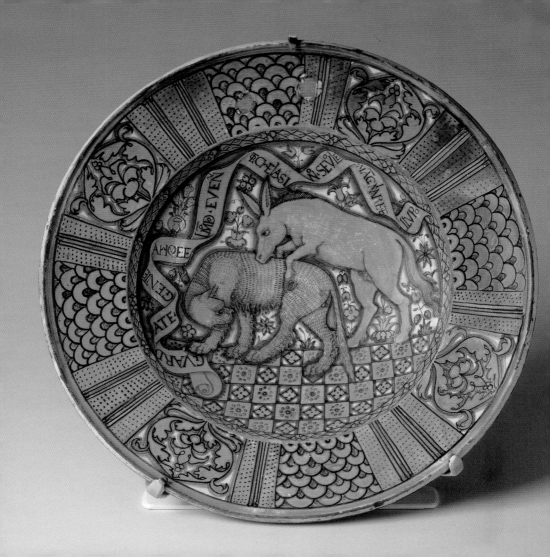

21. Tuscany, Dish, *late fifteenth century (Corcoran Gallery of Art, Washington, D.C.). This painted dish, based on a tarot card, depicts the meeting in 1354 of the Holy Roman Emperor Charles IV and the poet and scholar Francesco Petrarch.*

humanists made this image appealing; it could stimulate conversation on everything from politics to literature when it was used at, or put on display near, a table.

But maiolica was incorporated into daily life in ways that went beyond the dinner table and sideboard. The Corcoran's sixteenth-century Tuscan tile illustrates the story of Saint Martin of Tours sharing his cloak with a beggar; he was a popular saint in Tuscany, where he was patron saint of wine merchants and dedicatee of many churches (figure 22).[65] The original placement of this tile is therefore difficult to determine. But a floor covered in these brilliantly painted and utilitarian tiles would have made an impressive aesthetic impact. We know, for instance, that the floor of the library of Cardinal Aeneas Silvius Piccolomini in the Siena Cathedral was covered in triangular tiles bearing his crescent-moon heraldry in 1507.[66] Small spaces were particularly suitable for tile flooring. Maria Benedetti, the abbess of a Parma convent, ordered tiles for the floor of her prayer cell. Isabella d'Este lined the floor of one of her Mantua studies with tiles painted with her husband's heraldry and personal symbols.

on current politics in his compositions.[63] One of the few wares depicting a more recent event is a late-fifteenth-century Tuscan dish with the meeting of the Italian poet Francesco Petrarch and the Holy Roman Emperor Charles IV in December 1354; like much *istoriato,* this image is partly based on a print source, in this case a tarot card (figure 21).[64] Petrarch's popularity with Renaissance

(opposite) 20. Deruta, Dish with an Allegorical Scene, *circa 1520-25 (Corcoran Gallery of Art, Washington, D.C.). This* piatto da pompa *has an inscription that translates, "See, people, to what the world has come when the ass, if he wants to, can eat the wolf."*

22. Tuscany, Tile, *early sixteenth century (Corcoran Gallery of Art, Washington, D.C.). The story of Saint Martin of Tours sharing his cloak with a beggar was popular in Tuscany, where he was the patron saint of wine merchants.*

This was not just a way to honor her husband; a letter reveals the expectation that the impermeable tiles would be a deterrent to the rats living under the floorboards. Such a practical measure would be a good reason for tile flooring in almost any setting.[67]

Special maiolica containers came in unexpected shapes and sizes. The Corcoran's late-sixteenth-century quadrilateral flask from the Patanazzi workshop might have been used in a study, to hold various utensils or accessories appropriate to the owner's interests (figure 23); during the Renaissance, the study was an important room that allowed the owner to claim a part of the civility, manners, and education of the ruling elite.[68] Especially interesting, in this context, is the proliferation of maiolica inkstands. Inkstands were functional things, closely associated with literacy. In order to write, one must of course read, but more than half

23. Urbino, Patanazzi Workshop, *Quadrilateral Flask, circa 1580-90 (Corcoran Gallery of Art, Washington, D.C.). Saint John the Baptist, identifiable by his camel-skin shirt, is painted on this unusually shaped container.*

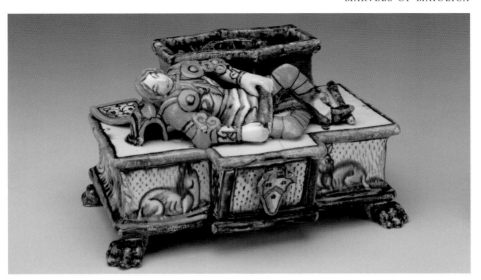

24. Faenza, Inkstand with a Sleeping Knight, *early sixteenth century (Corcoran Gallery of Art, Washington, D.C.). Inkstands, which celebrated their owners' literacy, came in a fantastic array of shapes.*

the male population—and even more of the female—was illiterate at this time.[69] Possession of an inkstand was therefore testament to the owner's education and erudition. And inkstands allowed ceramists a great deal of liberty in sculptural design, resulting in some truly fantastic three-dimensional figural compositions. The 1609 inventory of the Palazzo Ducale in Urbino included a number of complicated inkstands ornamented with statuettes of various figures, including a dead Christ with angels, Orpheus surrounded by animals, and Atlas carrying the world on his shoulders.[70] The inkstand at the Corcoran is a particularly inventive composition with a sleeping knight reclining on a footed dais (figure 24).[71] The ink container is alongside him, and a drawer for pens and other equipment is below. The heraldry may suggest this inkstand was part of a marriage gift, because it was common to purchase works embellished

39

25a. Deruta, Votive Plaque (front), 1505 (Corcoran Gallery of Art, Washington, D.C.). According to the inscription around the rim, this plaque was commissioned by a man named Iobe who, together with his three children, asked the Virgin Mary to aid the two sick women in his household.

25b. Deruta, Votive Plaque (back), 1505 (Corcoran Gallery of Art, Washington, D.C.). This back of this plaque is inscribed with the year and the letter G, making it one of the earliest marked and dated plaques known.

with coats-of-arms to mark the occasion.[72]

Devotional objects were also made from maiolica. Francesco Fori of Florence had a terracotta *Madonna and Child* by the Della Robbia workshop, which produced a type of tin-glazing slightly different from that used by maiolica artists.[73] The Ducal Palace in Urbino had two nativity sets made up of various figures.[74] Other patrons commissioned votive plaques in hope of or in gratitude for saintly intervention. The church of Madonna

dei Bagni near Deruta still has over 600 of these maiolica votives, dating from the seventeenth century to the present.[75] But the Corcoran's plaque is an unusually early example, dated 1505 on the front and inscribed "in Deruta" on the back, with a prominent letter "G" that probably represents the ceramist's initial (figure 25a and 25b).[76] According to the inscription, the patron's name was Iobe, and he and his three children asked the Virgin Mary to care for the

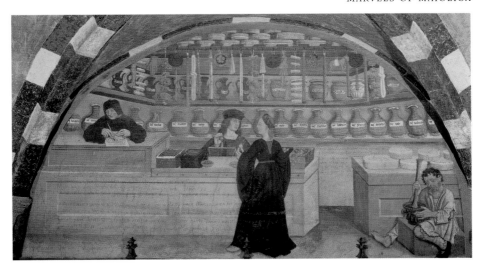

26. Italian, Apothecary Shop, *circa 1500 (Castello d'Issogne, Valle d'Aosta). This fresco shows rows of carefully labeled maiolica drug jars on the custom-built shelving behind the counter.*

two sick women in his home. The large canopied bed, with green hangings, orange linens, and heavy surrounding chests, indicates a certain level of prosperity, as does the fact that Iobe commissioned a plaque with such a personal iconography and inscription.

A significant quantity of maiolica was made for apothecaries. Apothecaries were important institutions in the Renaissance; whether attached to monasteries or hospitals, or as independent shops in the city streets, they attracted customers looking for medical advice, treatments, foodstuffs, and confections. They grew in numbers following the recurring outbreaks of plague from the mid-fourteenth century on, which increased the need for medical care. As popular gathering places for all members of society, the shops were furnished comfortably and they displayed their stock on rows of shelves for all to see (figure 26). This stock consisted of minerals, herbs, spices, sweets, and oils, all of which were combined in various ways to treat whatever ailment or defi-

41

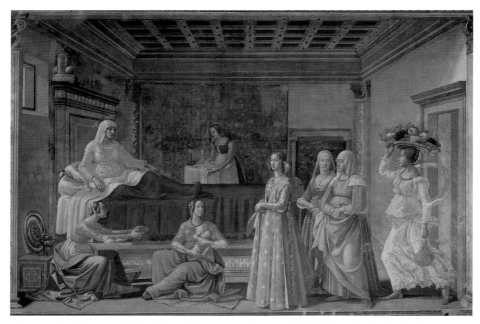

27. *Domenico Ghirlandaio,* Birth of Saint John the Baptist, *circa 1486-87 (Santa Maria Novella, Florence). Renaissance viewers recognized that the jar on Saint Elizabeth's headboard in this fresco would have contained medicine necessary for the care of the new mother or her child.*

ciency the patient presented. The fantastic array of goods found at apothecaries was well known; the fourteenth-century author Giovanni Boccaccio described a worldly friar's cell, "full of drug jars filled with ointments and unguents, of boxes full of varied sweets, of bottles and flasks with liquors and oils, of casks of Malmsey and Cyprian wines and other most precious vintages, so that they do not seem to be friars' cells but shops of apothecaries and perfumers."[77]

Each of these ingredients was stored in its own individual jar because the treatments were mixed on demand; apothecaries might

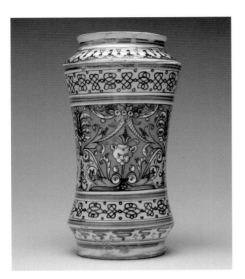

28. Siena, Albarello, circa 1510-15 (Corcoran Gallery of Art, Washington, D.C.). The waisted shape of this tall drug jar made it easy to grasp as it was taken down from a shelf.

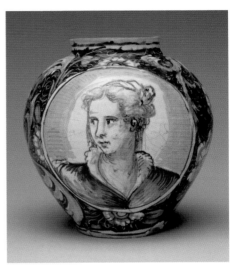

29. Venice, Workshop of Domenico da Venezia, Drug Jar with Heads of Women, *circa 1550-70 (Corcoran Gallery of Art, Washington, D.C.). This globular drug jar was probably once part of a set, all similarly painted with contemporary heads.*

order hundreds of similarly decorated drug jars in different shapes and sizes to hold their stock. Some were inscribed with the name of their contents, while others were more flexible and labeled with ephemeral, and changeable, paper tags. Some had maiolica stoppers or caps, but most were closed only with pieces of parchment or leather tied around their lips. The constant

production of drug jars must have helped many maiolica workshops achieve and maintain commercial success during this time. The production of drug jars was a lucrative business; the hospital of Santa Maria Nuova in Florence ordered almost one thousand jars from the ceramist Giunta di Tugio in 1430. Only a small number survive today, but they are recognizable by the crutch

43

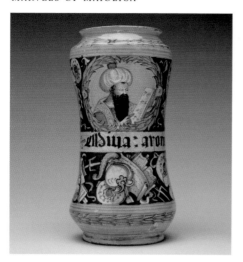

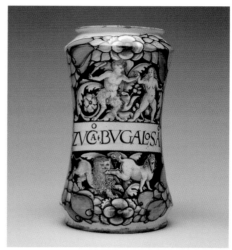

30. Faenza, Albarello with a Turk's Head and Trophies, *circa 1550-75 (Corcoran Gallery of Art, Washington, D.C.). The inscription indicates that this drug jar held an aromatic medicinal.*

31. Deruta, Albarello with Nymph and Satyr, *1507 (Corcoran Gallery of Art, Washington, D.C.). A restorative cordial of sugared borage, a common herb with small blue flowers, once filled this container.*

device of the hospital incorporated into their painting.[78] Other drug jars were probably used in homes; in an era that placed great faith in household remedies, it was common to keep some on hand, and certain paintings betray this role. For example, a jar sits on the headboard in Domenico Ghirlandaio's fresco of *The Birth of Saint John the Baptist* (figure 27). The Renaissance viewer would have understood it to contain a medicinal neces-

sary for the care of the new mother or her child. This type of jar, an *albarello* (the name may have come from the Arabic *al barani,* or container), could hold almost any type of curative, and its tall waisted shape made it easy to grasp and remove from a shelf, either at home or in a shop.[79]

The Corcoran has drug jars from several different maiolica centers; however, unlike the Santa Maria Nuova wares, we cannot

assign these jars to any particular apothecaries. An unlabelled *albarello* from Siena is painted with elaborate bands of grotesque ornament (figure 28). Another unlabeled jar, from the Venetian workshop of Domenico da Venezia, has a pair of female heads on either side (figure 29). A third, from Faenza, is painted with a Turk's head and trophy motifs; the inscription indicates that it held an aromatic medicinal (figure 30). An

albarello from Deruta, dated 1507, belongs to a group of variously shaped vessels painted with fantastic figures cavorting within decorative ornament; it has a satyr chasing a nude nymph, grasping her wrist and raising a club to subdue her, as well as a fight between a horse and a lion (figure 31).[80] According to the inscription, it held a restorative cordial of sugared borage.[81]

Perhaps the best-known drug jars are the

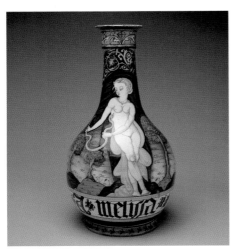

32. Castelli, Workshop of Orazio Pompeii, Tall Drug Jar with Cleopatra Contemplating the Asp, *mid-sixteenth century (Corcoran Gallery of Art, Washington, D.C.). This drug jar held lemon balm, which was good for aches, congestion, and colds.*

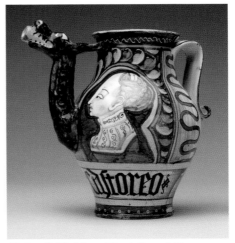

33. Castelli, Workshop of Orazio Pompeii, Dragon-Spouted Drug Jar with Busts of Women, *mid-sixteenth century (Corcoran Gallery of Art, Washington, D.C.). This jar, with its whimsical dragon spout, was used to store an anti-depressant oil made from beaver gland secretions.*

45

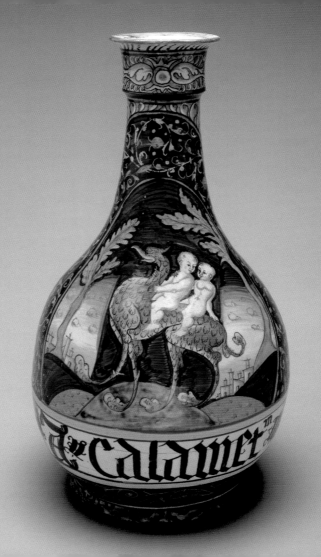

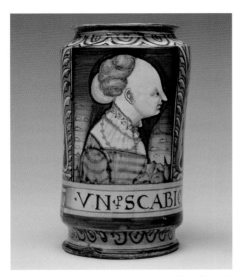

35. *Castelli, Workshop of Orazio Pompeii,* Albarello with Bust of a Woman, *mid-sixteenth century (Corcoran Gallery of Art, Washington, D.C.). The inscription reveals that a treatment for scabies, an itchy skin condition caused by tiny burrowing mites, was kept in this jar.*

(thought to be the symbol of the Orsini family) embracing a column (thought to be the symbol of the Colonna family) and the motto "and we shall be good friends," although there is no known apothecary associated with either family. In recent years excavations in the town of Castelli unearthed pottery shards identical to the wares in this group, identifying Orazio Pompeii and his workshop as the ceramists responsible for the Orsini-Colonna group.[82] Pompeii's workshop likely made several different sets for different apothecaries because repetitions occur within the group; as we know it today, the group must represent several different commissions. The wares were painted with a limited range of recognizable figure types and sacred and historical subjects, complemented by decorative designs and identifying inscriptions. According to these inscriptions, the Corcoran jars contained aqueous lemon balm, used to overcome aches, congestions, and colds (figure 32), a pungent oil made from the perineal glands of beavers and used to treat depression (figure 33), an aqueous solution of calamint, prized for its ability to bring about both menstruation and urine (figure 34), and

so-called Orsini-Colonna group; the Corcoran holds thirteen of the nearly 300 variously shaped jars associated with this group. The name derives from a vase in the British Museum painted with a bear

(opposite) 34. *Castelli, Workshop of Orazio Pompeii,* Tall Drug Jar with Two Babies Riding a Griffin, *mid-sixteenth century (Corcoran Gallery of Art, Washington, D.C.). This is one of hundreds of jars from the workshop of Orazio Pompeii, who appears to have stocked several different apothecaries with sets of similarly painted jars.*

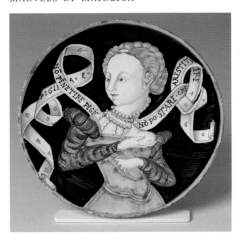

36. Castelli, Workshop of Orazio Pompeii, Dish with an Allegorical Subject, *circa 1520-40 (Corcoran Gallery of Art, Washington, D.C.). The scroll on this provocative dish translates as, "Take and don't regret it. The worst that can happen is that you would have to give it back."*

scroll behind her proclaims, "Take and don't regret it. The worse that could happen is that you would have to give it back." Indicative of the early-sixteenth-century love of both humor and sexual innuendo—indeed the same impulse that popularized the *I Modi* prints discussed earlier—this plate also fits well within a recognized genre of erotically charged maiolica wares.[85] Although we remain perplexed over the intended audience and function of such a dish, it surely relates to the idea of conviviality evident in some of the display plates discussed earlier. Its sexual message, however, implies that it was displayed only among a very select, and certainly literate, group of guests.[86]

Finally, maiolica could be used to celebrate the rituals of daily life. A Corcoran plate, inscribed "Beautiful Camilla," and dated 1541, was both manufactured and lustered in the town of Gubbio (figure 37).[87] It is a *bella donna* plate, a type produced between 1520-40 and notable for busts of young women surrounded by speaking scrolls with the word "beautiful" (*bella*) and a female name. Scholars often refer to these plates as betrothal or marriage gifts. The names are often unusual, indicating an origin more in the classical past than in

an unguent for treating scabies (figure 35).[83]

The Corcoran also has an unusual low-footed dish from Pompeii's workshop, one of only two works from the shop not obviously associated with apothecary wares (figure 36).[84] This dish displays an explicit sexual message: a woman holds her exposed breast in one hand, and a bird in the other (a phallic symbol since antiquity), while a

(opposite) 37. Gubbio, Plate, *1541 (Corcoran Gallery of Art, Washington, D.C.). This type of* bella donna *(beautiful lady) plate may have been used to celebrate an engagement or wedding.*

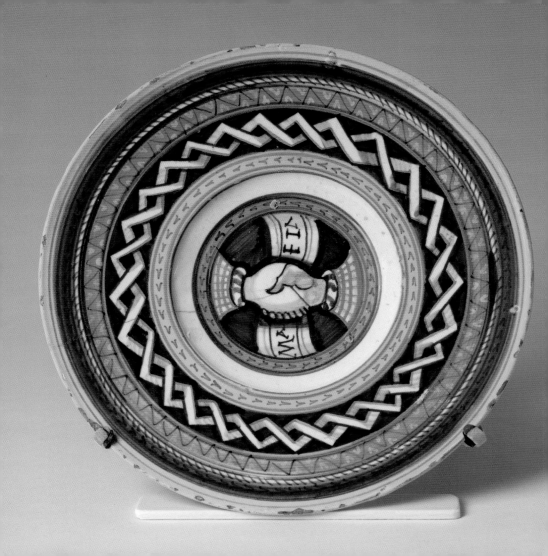

Renaissance Italy, where parents tended to bestow a relatively narrow range of biblical or saintly names on their children.[88] Classical names became a fashion for the elite in the sixteenth century, but we cannot assume that all the *bella* plates were made for the highest levels of society. Yet these plates seem to relate to contemporary texts about famous local women, who might be flattered to receive a *bella donna* plate attesting to their exemplary character and status. The woman in the Corcoran plate wears contemporary costume; her dress fabric has a fantastic iridescent stripe, and she has a red coral necklace with a hanging branch around her neck. Coral was talismanic, thought to be beneficial against a wide variety of ailments, from the Evil Eye to hemorrhaging. Camilla is, therefore, both very fashionable and well protected, and her presence at a table might inspire discussion on anything from the virtues of women to the legendary Camilla herself, the virgin queen of the Volscians in Virgil's *Aeneid*.[89] Also related to marriage is a small plate from Faenza, with concentric motifs surrounding a pair of clasped hands, a symbol of fidelity (figure 38).[90] Prior to the doctrinal changes established by the Council of Trent in the late sixteenth century, hand clasping sealed a marriage. A couple pledged their willingness to wed by affirming it verbally in front of witnesses while joining hands.[91] Such a plate might therefore be a wedding gift or commemoration, perhaps passed from one family to the other on the occasion.

Maiolica was also presented to women to encourage, celebrate, and commemorate childbirth (figure 39). These gifts could be in the form of single bowls or elaborate multi-ware stacking sets, where each ware held a particular type of food considered necessary for the mother's post-natal care. Surviving examples reveal that the exteriors had the same landscape scenes or fanciful *grottesche* common to much maiolica. But the insides of the bowls or the tops of the trays typically depict confinement room scenes or actual births, set in contemporary homes. Such scenes were appropriate because the primary audience was pregnant women or new mothers. They documented the world of childbirth in an affluent environment filled with the details of daily life; canopied beds, carved mantelpieces, and rocking cradles made up the setting, and the

(opposite) 38. Faenza, Plate with Clasped Hands, *late fifteenth–early sixteenth century (Corcoran Gallery of Art, Washington, D.C.). This plate probably commemorates the joining of two families in marriage with an image of two joined hands.*

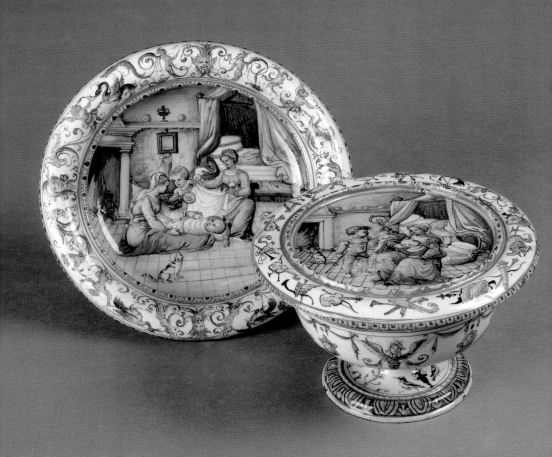

utmost care was devoted to the mother and her newborn. The undersides, however, were usually painted with naked boys. Only the mother, who used these intimate gifts, would have seen them. These boys seem to be talismanic; looking at them before a birth was thought to help a woman produce a healthy son, the unspoken goal of most pregnancies in that patriarchal age.[92]

The great quantity of surviving Renaissance ceramics reveals that it was a prized possession, carefully tended through the centuries and even repaired when broken. For example, Isabella d'Este sent an earthenware plate to Ferrara for repair, instead of discarding it. Francesco Inghirrami's 1471 Florentine estate included six pieces of maiolica that were important enough to inventory, even though they were described as broken. And the Dukes of Urbino, despite the presence of several hundred maiolica wares of various shapes and sizes in their storage, still kept those that were damaged.[93] All of this implies that maiolica was valued and not entirely replaceable; even elite patrons, who might be able to afford new pieces, tried to fix their old ones.

Maiolica held a significant place in Renaissance social life. Collectors displayed it in prominent locations, citizens from all levels of society gave it as gifts, notaries referred to it in documents, and merchants imported it from both neighboring city-states and farther afield. At table, maiolica served several purposes, including the most practical one of presenting, serving, and holding things to eat and drink. It was used in apothecaries, and it played an important role in marriage and childbirth rituals. The sophisticated and oftentimes complicated compositions on maiolica were intended to spark conversation, encourage sociability, and demonstrate erudition. Ultimately these decorative and above all useful ceramics took on a prominent role in the life of the Renaissance consumer, achieving a value beyond their inherent material worth. In this way, maiolica helps us better understand life in Renaissance Italy, a complex period that was filled with a range of functional and beautiful objects that both served and enhanced the lives of its citizens.

(opposite) 39. Urbino, Workshop of Orazio Fontana, Childbirth Bowls and Tray, *1560-70 (Detroit Institute of Arts). Mothers received stacking sets of maiolica wares like this one to encourage, celebrate, and commemorate the birth of their children.*

For good advice and maiolica insights, I am always grateful to Dora Thornton, Wendy Watson, and Timothy Wilson; Michael Brody and Caroline P. Murphy offered valuable assistance on this essay with their usual generosity and good humor. My research assistant, Crystal Sperbeck, provided enormous support during the writing process. This essay, and the exhibition that occasioned it, relies on the earlier catalogue of the collection by Wendy M. Watson, *Italian Renaissance Maiolica from the William A. Clark Collection* (London, 1986).

JMM

Notes

1. Leon Battista Alberti (trans. Guido A. Guarino), *The Albertis of Florence: Leon Battista Alberti's Della Famiglia* (Lewisburg, 1971), especially 160-173; Richard A. Goldthwaite, *Wealth and the Demand for Art in Italy 1300-1600* (Baltimore, 1993), 210-211; Raffaella Sarti (trans. Allan Cameron), *Europe at Home. Family and Material Culture 1500-1800* (New Haven, 2002), 127-128.

2. Richard A. Goldthwaite, "The Empire of Things: Consumer Demand in Renaissance Italy," in *Patronage, Art, and Society in Renaissance Italy*, ed. F.W. Kent and Patricia Simons with J.C. Eade (New York, 1987), 153-175. The term comes from the description of Maria Gostrey's famously crowded and fashionable Parisian apartment in Henry James's *The Ambassadors*.

3. Kenneth Clark, *The Drawings of Leonardo da Vinci in the Collection of Her Majesty the Queen at Windsor Castle* (London, 1968), I, 176.

4. Rosamond E. Mack, *Bazaar to Piazza. Islamic Trade and Italian Art, 1300-1600* (Berkeley, 2002), 2-3.

5. Even in Urbino, a city known for its own local ceramics, the Ducal family had ninety-one white vases made in Faenza (Fert Sangiorgi, ed., *Documenti urbinati. Inventari del Palazzo Ducale (1582-1631)* (Urbino, 1976), 196).

6. On Polo, see Marco Polo (trans. Ronald Latham), *The Travels of Marco Polo* (Harmondsworth, 1982), 238. For information on the influx and collectibility of eastern porcelain, see Marco Spallanzani, *Le ceramiche orientali a Firenze nel Rinascimento* (Florence, 1978). On the word porcelain, see Wendy M. Watson, *Italian Renaissance Maiolica from the Howard I. and Janet H. Stein Collection and the Philadelphia Museum of Art* (Philadelphia, 2001), 47. Soft paste porcelain, however, was made in the Florentine Ducal workshops by the late sixteenth century; see Galeazzo Cora, *La porcellana dei Medici* (Milan, 1986).

7. On Isabella's imitation porcelain, see Giuseppe Campori, *Maiolica e porcellana di Ferrara nei secoli XV e XVI* (Pesaro, 1879), 29-30, and Alessandro Luzio, *Isabella d'Este e il sacco di Roma* (Milan, 1908), 87-101. For information on Isabella's relationship with luxury goods and their providers I am grateful to Deanna Shemak.

8. Cipriano Piccolpasso (trans. and ed. Ronald Lightbown and Alan Caiger-Smith), *I tre libri dell'arte del vasaio* (London, 1980); see also Stephen J. Wharton, *Cipriano Piccolpasso and the Libro del Vasaio*, Ph.D dissertation, University of Sussex (forthcoming).

9. Timothy Wilson, "The Beginnings of Lusterware in Renaissance Italy," in *The International Ceramics Fair and Seminar* (London, 1996), 35-43.

10. Marco Spallanzani, "Un invio di maioliche ispano-moresche a Venezia negli anni 1401-1402," *Archeologia medievale* 5 (1978), 529-541.

11. J.V.G. Mallet and Franz Adrian Dreier, *The Hockemeyer Collection. Maiolica and Glass* (Bremen, 1998), 12.

12. On Roman customs, see Arnold Esch, "Roman Customs Registers 1470-80: Items of Interest to Historians of Art and Material Culture," *Journal of the Warburg and Courtauld Institutes* 58 (1995), 85-86; for imported maiolica, see Ellen Callmann, *Beyond Nobility. Art for the Private Citizen in the Early Renaissance* (Allentown, 1980), 92-93, Patricia Lee Rubin and Alison Wright, *Renaissance Florence. The Art of the 1470s* (London, 1999), 322-323, Anthony Ray, "The Rothschild Alfabeguer and Other Fifteenth-Century Spanish Lustered 'Basil Pots,'" *Burlington Magazine* 142 (June 2000), 371-375, and Luke Syson and Dora Thornton, *Objects of Virtue. Art in Renaissance Italy* (London, 2001), 202-203; on affordability, see Marco Spallanzani, "Maioliche di Valenza e di Montelupo in una casa Pisana del 1480," *Faenza* 72 (1986), 164-170.

13. Watson, 2001, 100; for Maestro Giorgio see Tiziana Biganti, *Maestro Giorgio Andreoli nei documenti eugubini (registi 1488-1575): Un contributo alla storia della ceramica del cinquecento* (Florence, 2002).

14. Leandro Alberti, *Descrittione di tutta Italia* (Bologna, 1550), 85.

15. For the derivation of the word *credenza*, and its implications for maiolica, see Mallet and Dreier, 1998, 33-34. Excerpted inventories of the plate found in homes of different social classes are published in *L'oreficeria nella Firenze del quattrocento* (Florence, 1977), 268-272.

16. Richard A. Goldthwaite, "The Economic and Social World of Italian Renaissance Maiolica," *Renaissance Quarterly* 42 (Spring 1989), 2-15.

17. On painted furnishings, and their messages, see Ellen Callmann, "The Growing Threat to Marital Bliss as Seen in Fifteenth-Century Florentine Paintings," *Studies in Iconography* 5 (1979), 73-92; Paul F. Watson, *The Garden of Love in Tuscan Art of the Early Renaissance* (Philadelphia, 1979); Anne B. Barriault, *Spalliera Paintings of Renaissance Tuscany. Fables of Poets for Patrician Homes* (University Park, 1994); Cristelle L. Baskins, *Cassone Painting, Humanism, and Gender in Early Modern Italy* (Cambridge, 1998); and Jacqueline Marie Musacchio, *The Art and Ritual of Childbirth in Renaissance Italy* (London, 1999).

18. Grazia Biscontini Ugolini and Jacqueline Petruzzellis Scherer, ed., *Maiolica e incisione: Tre secoli di rapporti iconografici* (Vicenza, 1992) and Watson, 2001, 111-128.

19. On figures 7 and 8 see Watson, 1986, 124-126 and 136-138.

20. On *I Modi* and Renaissance sexuality, see Bette Talvacchia, *Taking Positions. On the Erotic in Renaissance Culture* (Princeton, 1999) and Rudolph M. Bell, *How to Do It. Guides to Good Living for Renaissance Italians* (Chicago, 1999). On Xanto's transformations from prints to plates, see Bette Talvacchia, "Professional Advancement and the Use of the Erotic in the Art of Francesco Xanto," *Sixteenth-Century Journal* 25 (Spring 1994), 121-153.

21. Regarding *grottesche* on maiolica, see Christopher Poke, "Jacques Androuet I Ducerceau's 'Petites Grotesques' as a Source for Urbino Maiolica Decoration," *Burlington Magazine* 143 (June 2001), 332-344; on the Golden House of Nero, see Nicole Dacos, *La découverte de la Domus Aurea et la formation des grotesques à la Renaissance* (London, 1969). On figures 10a and 10b, see Watson, 1986, 154-155.

22. On the purchase of 200 pieces, see Syson and Thornton, 2001, 200; on the 84-piece service, see Goldthwaite, 1989, 20.

23. E. Sarasino De Mauri, *Le maioliche di Deruta* (Milan, 1924), 20.

24. For maiolica with Este heraldry, see Elisabetta

Barbolini Ferrari and Giorgio Boccolari, *Ceramiche nel ducato Estense dal XVI al XIX secolo* (Bologna, 1997), especially 13-26; for the Farnese, see Romualdo Luzi and Carmen Ravanelli Guidotti, *Nel segno del giglio. Ceramiche per i Farnese* (Viterbo, 1993); and for the Medici, see Gian Carlo Bojani, *Ceramica e araldica medicea* (San Savino, 1992). On figure 11, see Watson, 1986, 64-65.

25. Paride Berardi, *L'antica maiolica di Pesaro dal XIV al XVII secolo* (Florence, 1984), 32 and Oreste Delucca, *Ceramisti e vetrai a Rimini in età Malatestiana. Rassegna di fonti archivistiche* (Rimini, 1998), 191.

26. Marco Spallanzani and Giovanna Gaeta Bertelà, ed., *Libro d'inventario dei beni di Lorenzo il Magnifico* (Florence, 1992).

27. Translated from Giorgio Vasari (ed. Gaetano Milanesi), *Le vite de'più eccellenti pittori, scultori ed architettori* (Florence, 1878-1885), VI, 581-582.

28. Syson and Thornton, 2001, 214.

29. On services, see Otto Mazzucato, "Sulla definizione del 'servizio da tavola' nella ceramica," *Atti Albisola* 15 (1982), 19-35; Michael J. Brody, "The Evolution, Function, and Social Context of Italian Renaissance Maiolica Services, circa 1480 – 1600," Ph.D dissertation, University of Oxford (forthcoming); and Michael J. Brody, "'Terra d'Urbino tutta dipinta a paesi con l'armi de'Salviati': The *Paesi* Service in the 1583 Inventory of Jacopo di Alamanno Salviati (1537-1586)," *Faenza* 86 (2000), 36 note 13. On the other hand, someone might have only a single piece; in 1539, the estate of Ghuglielmo Scharapucci included one *istoriato* plate (Archivio di Stato, Florence, *Magistrato dei Pupilli del Principato* (henceforth *MPP*) 2647, 65 verso). Perhaps this was all that remained of Scharapucci's once larger service due to attrition, or perhaps it was a single display piece.

30. Watson, 1986, 132-134. For this service see Julia Triolo, "Fra Xanto Avelli's Pucci Service (1532-1533): A Catalogue," *Faenza* 74 (1988), 32-44 and 228-284, "New Notes and Corrections to 'The Pucci Service: A Catalogue'," *Faenza* 78 (1992), 87-89, and "L'Urbs e l'Imperator: A Proposal for the Reinterpretation of the Pucci Service by Xanto Avelli," in Timothy Wilson, ed., *Italian Renaissance Pottery. Papers Written in Association with a Colloquium at the British Museum* (London, 1991), 36-45. Thirty-two pieces are illustrated in Jörg

Rasmussen, *The Robert Lehman Collection X. Italian Maiolica* (Princeton, 1989), 252-257.

31. Watson, 1986, 112-114. For this service see Catherine Hess, *Italian Ceramics. Catalogue of the J. Paul Getty Museum Collection* (Los Angeles, 2002), 144-149, and Celia Curnow, *Italian Maiolica in the National Museums of Scotland* (Edinburgh, 1992), 59-63.

32. Watson, 1986, 102-103. For two related jars, see Bernard Rackham, *Victoria and Albert Museum. Catalogue of Italian Maiolica* (London, 1940), I, 65-66.

33. Watson, 1986, 148-150. German patronage is discussed in Julia Fritsch, "Services destinés à l'Allemagne," in Thierry Crépin-Leblond and Pierre Ennès, ed., *Le dressoir du prince: Services d'apparat à la Renaissance* (Ecouen, 1995), 68-80.

34. J.V.G. Mallet, "Mantua and Urbino: Gonzaga Patronage of Maiolica," *Apollo* 114 (1981), 162-164 and Mallet and Dreier, 1998, 33-39. For evidence of the use of imported eastern porcelain, see Spallanzani, 1978, 130.

35. Archivio di Stato, Florence, *Magistrato dei Pupilli avanti il Principato* (henceforth *MPAP*) 160, 433 verso.

36. Daniela Romagnoli, "'Mind Your Manners.' Etiquette at the Table," in Jean-Louis Flandrin and Massimo Montanari, ed., *Food. A Culinary History from Antiquity to the Present*, (New York, 2000), 332 and Watson, 2001, 151. Michel de Montaigne and Fynes Moryson, both writing in the late sixteenth century, commented on the use of individual forks in Italy; see Goldthwaite, 1993, especially 246-247.

37. Spallanzani and Bertelà, 1992, 60, 72, 94, 141, 171, 182, 226, and 243.

38. David Herlihy (ed. Samuel K. Cohn Jr.), *The Black Death and the Transformation of the West* (Cambridge, 1997).

39. On new crops, see Goldthwaite, 1989, 23; on new objects, see Sergio Bertelli and Giuliano Crifò, ed., *Rituale, cerimoniale, etichetta* (Milan, 1985) and Giancarlo Malacarne, *Sulla mensa del principe. Alimentazione e banchetti alla corte dei Gonzaga* (Modena, 2000); and on cookbooks, see Santa Nepoti Frescura, "Cucina e ceramica nei ricettari dei secoli XIV – XVII," *Atti Albisola* 9 (1976), 129-147.

40. MPP 2647, 226 verso.

41. Michel de Montaigne (trans. and ed. W.G. Waters), *The Journal of Montaigne's Travels in Italy by Way of Switzerland*

and Germany in 1580 and 1581 (New York, 1903), III, 154.

42. Archivio Capitolino, Rome, I Serie, 95, 105. For further information on Felice see Caroline P. Murphy, *The Pope's Daughter* (forthcoming).

43. Mary Bennett, *Artists of the Pre-Raphaelite Circle. The First Generation* (London, 1988), 118-126.

44. Marco Spallanzani, *Ceramiche alla corte dei Medici nel cinquecento* (Modena, 1994), 128-129; see also Mallet and Dreier, 1998, 36.

45. Syson and Thornton, 2001, 216; see also A. Rossi, "Documenti inediti per la storia delle maioliche," *Archivio storico dell'arte* 2 (1889), 308-309 and Timothy Wilson, "Italian Maiolica around 1500: Some Considerations on the Background to Antwerp Maiolica," in David Gaimster, ed., *Maiolica in the North. The Archaeology of Tin-Glazed Earthenware in North-West Europe Circa 1500-1600* (London, 1999), 6.

46. Giovanni Battista Barpo, *Le delitie e i frutti dell'agricoltura e della vina* (Venice, 1634), 12-13; for Giovanni Pontano's description of villa dining on earthenware see Carol Kidwell, *Pontano: Poet & Prime Minister* (London, 1991), 273.

47. On Strozzi, see Marco Spallanzani, "Un 'fornimento' di maiolica di Montelupo per Clarice Strozzi de'Medici," *Faenza* 70 (1994), 381-387. On Isabella, see Mariarosa Palvarini Gobio Casali, *La ceramica a Mantova* (Ferrara, 1987), 182; for more on this service, see Casali, 1987, 180-192 and David Chambers and Jane Martineau, ed., *Splendours of the Gonzaga* (London, 1981), 175-178.

48. For examples see Philippa Glanville and Hilary Young, ed., *Elegant Eating. Four Hundred Years of Dining in Style* (London, 2002).

49. Mallet, 1981, 167.

50. For Lombardo, see Cathy Santore, "Julia Lombardo, 'Somtuosa Meretrize': A Portrait by Property," *Renaissance Quarterly* 41 (Spring 1988), 73; for Salviati, see Brody, 2000, 44-45; for Medici, see Spallanzani, 1994, 191; for Gonzaga, see Carmen Ravanelli Guidotti, *Faenza-faience. "Bianchi" di Faenza* (Ferrara, 1996), 164; and for the Urbino Dukes see Sangiorgi, 1976, 189.

51. Rackham, 1940, I, 98-99. I am grateful to Michael Brody for this reference.

52. Crépin-Leblond and Ennès, 1995, 64-67, Mallet and Dreier, 1998, 35, and Syson and Thornton, 2001, 220-221.

53. Watson, 1986, 154-155.

54. J.K. Sowards, ed., *Collected Works of Erasmus* (Toronto, 1974), 25, 280-281.

55. Ovid (trans. Horace Gregory), *The Metamorphosis* (New York, 1958), 81-82 and 85-89.

56. Watson, 1986, 158-159; a flask with a similar shape is discussed in Hess, 2002, 186-191. For the story, see Ovid, 1958, 282-289.

57. For a similarly unwearable enameled copper flask, see Callmann, 1980, 102-103.

58. Watson, 1986, 86-87.

59. Hess, 2002, 112-117.

60. Watson, 1986, 88-89; for a similar plate see Curnow, 1992, 44.

61. Marta Ajmar, "Talking Pots: Strategies for Producing Novelty and the Consumption of Painted Pottery in Renaissance Italy," in *The Art Market in Italy (15th – 17th Centuries)*, ed. Marcello Fantoni, Louisa C. Matthew, and Sara F. Matthews-Grieco (Ferrara, 2003), 59.

62. Giovanni Pontano (ed. and trans. Francesco Tateo), *I trattati delle virtù sociali* (Rome, 1965), 141-155 and 281-293.

63. Watson, 1986, 34.

64. Watson, 1986, 32-34; for Petrarch's popularity, see Christian Bec, *Les livres des Florentins (1413-1600)* (Florence, 1984).

65. Watson, 1986, 178. For Saint Martin, see Herbert Thurston and Donald Attwater, ed., *Butler's Lives of the Saints* (New York, 1962), IV, 310-313, and George Kaftal, *Iconography of the Saints in Tuscan Painting* (Florence, 1952), 708.

66. Jorg Rasmussen, *Italienische Majolika. Kataloge des Museums für Kunst und Gewerbe, Hamburg* (Hamburg, 1984), 115-116.

67. Thornton, 1997, 46-49 and Julia Poole, *Italian Maiolica and Incised Slipware in the Fitzwilliam Museum, Cambridge* (Cambridge, 1995), 283-284.

68. For figure 23, see Watson, 1986, 160-161; on the study, see Thornton, 1997.

69. On literacy rates, see Paul F. Grendler, *Schooling in Renaissance Italy. Literacy and Learning, 1300-1600* (Baltimore, 1989), 74-78.

70. Sangiorgi, 1976, 186-192. For evidence of the truly fantastic nature of some inkstands, see Timothy Wilson, *Italian Maiolica of the Renaissance* (Milan, 1996), 384.

71. Watson, 1986, 40-41. For a similar inkstand, see Carmen Ravanelli Guidotti, *Thesaurus di opere della tradizione di Faenza nelle raccolte del Museo Internazionale delle Ceramiche in Faenza* (Faenza, 1998), 230-232.

72. For inkstands associated with marriage, see Giuseppe Liverani, "Di un calamaio quattrocentesco al Museo di Cluny," *Faenza* 61 (1975), 7-12 and J.V.G. Mallet, "Un calamaio in maiolica a Boston," *Faenza* 62 (1976), 79-85.

73. *MPP* 2660, 681 verso.

74. Sangiorgi, 1976, 264; for this type of nativity set, see Guidotti, 1998, 221-227.

75. See Giulio Busti, *Gli ex-voto in maiolica della Chiesa della Madonna dei Bagni a Casalina presso Deruta* (Florence, 1983) and Grazietta Guaitini and Tullio Seppilli, "Gli ex-voto in maiolica della Chiesa della Madonna dei Bagni presso Deruta," in Grazietta Guaitini, ed., *Antiche maioliche di Deruta per un museo regionale della ceramica umbra* (Rome, 1980), 49-53.

76. Watson, 1986, 76-77. This plaque is discussed in more detail in Timothy Wilson, "Deruta in the Early Development of Maiolica Istoriata," in *La ceramica umbra al tempo di Perugino e oltre* (Deruta, 2004). For a similar plaque, see Giulio Busti and Franco Cocchi, *Museo Regionale della Ceramica di Deruta. Ceramiche policrome, a lustro, e terracotta di Deruta dei secoli XV e XVI* (Milan, 1999), 188-189.

77. For Renaissance health care, see Katharine Park, *Doctors and Medicine in Early Renaissance Florence* (Princeton, 1985); a list of fifteenth-century Florentine apothecary shops is in Galeazzo Cora, *Maiolica di Firenze e del contado, secoli XVI – XV* (Florence, 1973), I, 239-240. See also Rudolph E.A. Drey, *Apothecary Jars* (London, 1978), and Sandra Giovannini and Gabriella Mancini (trans. Lisa Pelletti), *The Pharmacy of Santa Maria Novella* (Florence, 2002). The friar's cell passage is translated from Giovanni Boccaccio (ed. Mario Marti), *Decameron* (Milan, 1974), 462 (VII:3).

78. Regarding an apothecary buying stoppers, see Gabriella Mancini, *L'officina profumo-farmaceutica di Santa Maria Novella in Firenze. Sette secoli di storia* (Rome, 1994), 120. On the commercial success of apothecaries, see Timothy Wilson, "Preface," in Grazia Biscontini Ugolini, ed., *I vasi da farmacia nella collezione Bayer* (Pisa,

1997), 11. On the Santa Maria Nuova jars, see Hess, 2002, 56-61 and Rasmussen, 1989, 4-5.

79. On Renaissance childbirth and its necessary accessories and foodstuffs, see Musacchio, 1999, 35-57. On the word albarello, see John Norris, "Cultural Odyssey: *Materia Medica* and the Koerner Collection," in Carol E. Mayer, ed., *The Potter's Art. Contributions to the Study of the Koerner Collection of European Ceramics* (Vancouver, 1997), 135-136, note 4.

80. For figures 28, 29, 30, and 31, see Watson, 1986, 72-73, 172-173, 177, 84-85; on figures 30 and 31, see also Carola Fiocco, Gabriella Gherardi, and Liliane Sfeir-Fakhri, *Majoliques italiennes du Musée des Arts Décoratifs de Lyon. Collection Gillet* (Dijon, 2001), 48-50 and 93-94.

81. On borage, see Nicholas Culpeper, *Culpeper's Complete Herbal: Consisting of a Comprehensive Description of Nearly All British and Foreign Herbs with their Medicinal Properties and Directions for Compounding the Medicines Extracted from Them* (London, 1923), 57 and Maud Grieve, *A Modern Herbal. The Medicinal, Culinary, Cosmetic, and Economic Properties, Cultivation, and Folklore of Herbs, Grasses, Fungi, Shrubs, and Trees with all their Modern Scientific Uses* (New York, 1971), 119-120.

82. On the Corcoran's Orsini-Colonna group, see Watson, 1986, 54-57, 177-178. On the vase in the British Museum, see Timothy Wilson, *Ceramic Art of the Italian Renaissance* (London, 1987), 143. On Castelli, see Giorgio Baldisseri et al, *Le maioliche cinquecentesche di Castelli. Una grande stagione artistica ritrovata* (Pescara, 1989) and Fiocco, Gherardi, and Sfeir-Fakhri, 2001, 276-293.

83. On lemon balm, see Margaret Freeman, *Herbs for the Medieval Household for Cooking, Healing, and Divers Uses* (New York, 1943), 20; on beaver gland oil, see Casper Neumann, *Lectiones publicae von vier Subjectis Pharmaceuticis, nehmlich vom Succino, Opio, Caryophilis aromaticis, und Castoreo* (Berlin, 1730); on calamint, see Culpeper, 1923, 73, and Grieve, 1971, 153; and on scabies, see Watson, 1986, 178.

84. Watson, 1986, 58-59.

85. A particularly fascinating plate painted by Francesco Urbini with the ancient motif of a head made entirely of penises (and inscribed in reverse "every man looks at me as if I were a head of dicks") was acquired recently by the Ashmolean Museum; see Giovanni Conti and Gian Carlo Bojani, *Nobilissime ignobilità della maiolica istoriata* (Faenza, 1992), 102-103 and Catherine Hess, "Getting Lucky," in Paul Mathieu, *Sex Pots. Eroticism in Ceramics* (New Brunswick, 2003), 64-79. I thank Timothy Wilson for information on this plate.

86. The display of certain images for certain audiences was advocated by Giulio Mancini in his treatise *Considerazioni sulla pittura* (circa 1621), where he wrote that lascivious images should be covered and placed in private rooms for selective viewing.

87. Watson, 1986, 100-101. See also Marta Ajmar and Dora Thornton, "When is a Portrait Not a Portrait? *Belle Donne* on Maiolica and Renaissance Praise of Local Beauties," in Luke Syson and Nicholas Mann, ed., *The Image of the Individual: Portraits in the Renaissance* (London, 1998), 138-149.

88. Christiane Klapisch Zuber (trans. Lydia G. Cochrane), "The Name 'Remade': The Transmission of Given Names in Florence in the Fourteenth and Fifteenth Centuries," in her *Women, Family, and Ritual in Renaissance Italy* (Chicago, 1985), 283-309.

89. On Camilla in domestic furnishings, see Baskins, 1998, 75-102.

90. Watson, 1986, 44-45. For similar plates, see Elisabeth Reissinger, *Italienische Majolika. Kunstsammlungen zu Weimar* (Berlin, 2000), 38-39 and Giovanni Conti, *Una collezione di maioliche del rinascimento* (Milan, 1984), unpaginated.

91. For the handshake, see Christiane Klapisch-Zuber (trans. Lydia G. Cochrane), "Zacharias, or the Ousted Father: Nuptial Rites in Tuscany between Giotto and the Council of Trent," in her *Women, Family, and Ritual in Renaissance Florence* (Chicago, 1985), 178-212, and Margaret D. Carroll, "'In the Name of God and Profit': Jan Van Eyck's Arnolfini Portrait," *Representations* 44 (1993), 99-104.

92. Musacchio, 1999, 91-123.

93. On Isabella, see Campori, 1879, 12-13 and Goldthwaite, 1989, 27. On the Inghirammi, see *MPAP* 173, 270 verso. On the Dukes of Urbino, who had two trick jugs and two candleholders, with one of each described as broken, see Sangiorgi, 1976, 195; an example of a trick jug is in Watson, 2001, 174.

Illustrations

H = height
W = width
D = depth
Diam = Diameter

Watson = Wendy Watson, Italian Renaissance Maiolica from the William A. Clark Collection (London, 1986).

1. Leonardo da Vinci, *Rain of Goods*, ink drawing, circa 1510, The Royal Collection © 2003, Her Majesty Queen Elizabeth II, Windsor.

2. Map of Major Maiolica Centers in Italy, designed by Daniel Klein.

3. Cipriano Piccolpasso, *Ceramists Shaping Wares* from the manuscript *I tre libri dell'arte del vasaio*, folio 16, recto, circa 1557, Victoria and Albert Museum, London. V & A Picture Library.

4. Cipriano Piccolpasso, *Ceramists Painting Wares*, from the manuscript *I tre libri dell'arte del vasaio*, folio 57, verso, circa 1557, Victoria and Albert Museum, London. V & A Picture Library.

5. Urbino, Francesco Xanto Avelli da Rovigo, *Plate with The Sinking of the Fleet of Seleucus* (back), from the Pucci Service, 1532, tin-glazed earthenware, H 2.3 cm, Diam 25.8 cm, Corcoran Gallery of Art, Washington, D.C., William A. Clark Collection 26.361. [Watson 52]

6. Deruta, *Molded Dish with Judith and the Head of Holofernes*, circa 1525-30, tin-glazed earthenware, H 6.2 cm Diam 26.5 cm, Corcoran Gallery of Art, Washington, D.C., William A. Clark Collection 26.329. [Watson 34]

7. Urbino, Francesco Xanto Avelli da Rovigo, *Plate with The Massacre of the Innocents*, circa 1527-30, tin-glazed earthenware, H 5.5 cm, Diam 48.7 cm, Corcoran Gallery of Art, Washington, D.C., William A. Clark Collection 26.350. [Watson 49]

8. Urbino, Francesco Xanto Avelli da Rovigo, *Plate with The Battle of Roncevaux*, 1533, tin-glazed earthenware, H 4.5 cm, Diam 43.5 cm, Corcoran Gallery of Art, Washington, D.C., William A. Clark Collection 26.356. [Watson 53]

9. Marcantonio Raimondi after Giulio Romano, *Fragments of I Modi*, 1527, British Museum, London.

10a and 10b. Urbino, Fontana Workshop, Urbino, *Ewer Basin with Europa and the Bull and Cadmus and the Dragon*, circa 1565-75, tin-glazed earthenware, H 5 cm, Diam 45.1 cm, Corcoran Gallery of Art, Washington, D.C., William A. Clark Collection 26.317. [Watson 60]

11. Tuscany, probably Cafaggiolo, *Footed Dish with the Arms of the Medici*, circa 1513-21, tin-glazed earthenware, H 7.3 cm, Diam 22.3 cm, Corcoran Gallery of Art, Washington, D.C., William A. Clark Collection 26.303. [Watson 21]

12. Front of figure 5.

13. Urbino, Nicola da Urbino, *Plate with an Allegorical Scene of Calliope and a Youth*, from the Ladder Service, circa 1525-28, tin-glazed earthenware, H 4 cm, Diam 26.2 cm, Corcoran Gallery of Art, Washington, D.C., William A. Clark Collection 26.348. [Watson 45]

14a and 14b. Castel Durante or Urbino, *Vase with the Arms of Guidobaldo da Montefeltro of Urbino and Judith with the Head of Holofernes*, circa 1482-1508, tin-glazed earthenware, H 33, Diam 30 cm, Corcoran Gallery of Art, Washington, D.C., William A. Clark Collection 26.327. [Watson 40]

15. Urbino, *Plate with a Heraldic Design after Hans Sebald Lautensack*, circa 1552-63, tin-glazed earthenware, H 4.1 cm, Diam 24.1 cm, Corcoran Gallery of Art, Washington, D.C., William A. Clark Collection 26.370. [Watson 58]

16. Urbino, Fontana Workshop, *Dining Couple from an Inkstand*, sixteenth century, tin-glazed earthenware, Museo Civico, Pesaro.

17. John Everett Millais, *Lorenzo and Isabella*, oil on canvas, 1849, National Museums Liverpool (Walker Art Gallery).

18. Urbino, Fontana Workshop, *Pilgrim Flask with Myrrha and Adonis*, circa 1570-80, tin-glazed earthenware, Lid: H 8.2 cm, Diam 6 cm; Flask: H 48.9 cm, Diam 30 cm, Corcoran Gallery of Art, Washington, D.C., William A. Clark Collection 26.357. [Watson 62]

19. Deruta, *Dish with the Incarnation of the Virgin*, circa

1520-25, tin-glazed earthenware, H 9.2 cm, Diam 40.5 cm, Corcoran Gallery of Art, Washington, D.C., William A. Clark Collection 26.336. [Watson 32]

20. Deruta, *Dish with an Allegorical Scene*, circa 1520-25, tin-glazed earthenware, H 9.6, Diam 41.4 cm, Corcoran Gallery of Art, Washington, D.C., William A. Clark Collection 26.380. [Watson 33]

21. Tuscany, *Dish with Petrarch and Emperor Charles IV*, late fifteenth century, tin-glazed earthenware, H 7.4 cm, Diam 38.2 cm, Corcoran Gallery of Art, Washington, D.C., William A. Clark Collection 26.316. [Watson 1]

22. Tuscany, *Tile with Saint Martin and the Beggar*, early sixteenth century, tin-glazed earthenware, H 18.5 cm, W 17.6 cm Corcoran Gallery of Art, Washington, D.C., William A. Clark Collection. 26.310. [Watson 85]

23. Urbino, Patanazzi Workshop, *Quadrilateral Flask with Saint John the Baptist and Grotesques*, circa 1580-90, tin-glazed earthenware, H 24.5 cm, Base 10.5 x 10.5 cm, Corcoran Gallery of Art, Washington, D.C., William A. Clark Collection, 26.377 [Watson 63]

24. Faenza, *Inkstand with Sleeping Knight*, early sixteenth century, tin-glazed earthenware, H 13 cm, W 22 cm, D 16 cm, Corcoran Gallery of Art, Washington, D.C., William A. Clark Collection 26.415. [Watson 4]

25a and 25b. Deruta, *Votive Plaque*, 1505, tin-glazed earthenware, H 2 cm, Diam 34.8 cm, Corcoran Gallery of Art, Washington, D.C., William A. Clark Collection, 26.402. [Watson 27]

26. Italian, *Apothecary Shop*, fresco, circa 1500, Castello d'Issogne, Valle d'Aosta. Scala/Art Resource, NY.

27. Domenico Ghirlandaio, *Birth of Saint John the Baptist*, fresco, circa 1486-87, Santa Maria Novella, Florence. Scala/Art Resource, NY.

28. Siena, *Albarello with Grotesques and Ornamental Bands*, circa 1510-15, tin-glazed earthenware, H 27.5 cm, Diam 14.2 cm, Corcoran Gallery of Art, Washington, D.C., William A. Clark Collection, 26.334. [Watson 25]

29. Venice, Workshop of Domenico da Venezia, *Drug Jar with Female Heads*, circa 1550-70, tin-glazed earthenware, H 24 cm, Diam of mouth 11.2 cm, Corcoran Gallery of Art, Washington, D.C., William A. Clark Collection, 26.359. [Watson 69]

30. Faenza, *Albarello with a Turk's Head and Trophies*, circa 1550-75, tin-glazed earthenware, H 29.1 cm, Diam 14.3 cm, Corcoran Gallery of Art, Washington, D.C., William A. Clark Collection, 26.379. [Watson 76]

31. Deruta, *Albarello with Nymph and Satyr*, 1507, tin-glazed earthenware, H 23.3 cm, Diam 10.5 cm, Corcoran Gallery of Art, Washington, D.C., William A. Clark Collection, 26.419. [Watson 31]

32. Castelli, Workshop of Orazio Pompeii, *Tall Drug Jar with Cleopatra Contemplating the Asp*, mid-sixteenth century, tin-glazed earthenware, H 44 cm, Diam 20 cm, Corcoran Gallery of Art, Washington, D.C., William A. Clark Collection, 26.325. [Watson 16]

33. Castelli, Workshop of Orazio Pompeii, *Dragon-Spouted Drug Jar with Busts of Women*, mid-sixteenth century, tin-glazed earthenware, H 22.5 cm, D 15 cm Corcoran Gallery of Art, Washington, D.C., William A. Clark Collection, 26.389 [Watson 17].

34. Castelli, Workshop of Orazio Pompeii, *Tall Drug Jar with Two Babies Riding a Griffin*, mid-sixteenth century, tin-glazed earthenware, H 41.1 cm, D 22.9 cm, Corcoran Gallery of Art, Washington, D.C., William A. Clark Collection, 26.326. [Watson 79]

35. Castelli, Workshop of Orazio Pompeii, *Albarello with Bust of a Woman*, mid-sixteenth century, tin-glazed earthenware, H 21.2 cm, D 12.8 cm, Corcoran Gallery of Art, Washington, D.C., William A. Clark Collection 26.393. [Watson 84]

36. Castelli, Workshop of Orazio Pompeii, *Dish with an Allegorical Subject*, 1520-40, tin-glazed earthenware, H 4 cm, Diam 23.5 cm, Corcoran Gallery of Art, Washington, D.C., William A. Clark Collection, 26.308. [Watson 18]

37. Gubbio, *Plate with a Portrait of a Woman (Camilla)*, 1541, tin-glazed earthenware, H 6 cm, Diam 35.5 cm, Corcoran Gallery of Art, Washington, D.C., William A. Clark Collection 26.312. [Watson 39]

38. Faenza, *Plate with Clasped Hands*, late fifteenth–early sixteenth-century, tin-glazed earthenware, H 3 cm, Diam 23.7 cm, Corcoran Gallery of Art, Washington, D.C., William A. Clark Collection 26.406. [Watson 6]

39. Urbino, Workshop of Orazio Fontana, *Childbirth Bowls and Tray*, 1560-1570, tin-glazed earthenware, Detroit Institute of Arts, Founders Society Purchase, Mr. and Mrs. Henry Ford II Fund, Photograph © 1980 by The Detroit Institute of Arts

Checklist of the Exhibition

All works are Italian Renaissance maiolica from the William A. Clark Collection
at the Corcoran Gallery of Art, Washington, D.C.

1. Tuscany, probably Cafaggiolo, *Footed Dish with the Arms of the Medici*, circa 1513-21, tin-glazed earthenware, H 7.3 cm, Diam 22.3 cm, 26.303. [Watson 21] (fig. 11)

2. Castelli, Workshop of Orazio Pompeii, *Dish with an Allegorical Subject*, 1520-40, tin-glazed earthenware, H 4 cm, Diam 23.5 cm, 26.308. [Watson 18] (fig. 36)

3. Tuscany, *Tile with St. Martin and the Beggar*, early sixteenth century, tin-glazed earthenware, H 18.5 cm, W 17.6 cm, 26.310. [Watson 85] (fig. 22)

4. Gubbio, *Plate with a Portrait of a Woman (Camilla)*, 1541, tin-glazed earthenware, H 6 cm, Diam 35.5 cm, 26.312. [Watson 39] (fig. 37)

5. Tuscany, *Dish with Petrarch and Emperor Charles IV*, late fifteenth century, tin-glazed earthenware, H 7.4 cm, Diam 38.2 cm, 26.316. [Watson 1] (fig. 21)

6. Urbino, Fontana Workshop, *Ewer Basin with Europa and the Bull and Cadmus and the Dragon*, circa 1565-75, tin-glazed earthenware, H 5 cm, Diam 45.1 cm, 26.317. [Watson 60] (figs. 10a and 10b)

7. Castelli, Workshop of Orazio Pompeii, *Tall Drug Jar with Bearded Man wearing a Helmet*, mid-sixteenth century, tin-glazed earthenware, H 42 cm, Diam at mouth 10 cm, 26.324. [Watson 15]

8. Castelli, Workshop of Orazio Pompeii, *Tall Drug Jar with Cleopatra Contemplating the Asp*, mid-sixteenth century, tin-glazed earthenware, H 44 cm, Diam 20 cm, 26.325. [Watson 16] (fig. 32)

9. Castelli, Workshop of Orazio Pompeii, *Tall Drug Jar with Two Babies Riding a Griffin*, mid-sixteenth century, tin-glazed earthenware, 41.1 cm, Diam 22.9 cm, 26.326. [Watson 79] (fig. 34)

10. Castel Durante or Urbino, *Vase with the Arms of Guidobaldo da Montefeltro of Urbino and Judith with the Head of Holofernes*, circa 1482-1508, tin-glazed earthenware, H 33, Diam 30 cm, 26.327. [Watson 40] (figs. 14a and 14b)

11. Siena, *Albarello with Grotesques and Ornamental Bands*, circa 1510-15, tin-glazed earthenware, H 27.5 cm, Diam 14.2 cm, 26.334. [Watson 25] (fig. 28)

12. Deruta, *Dish with the Incarnation of the Virgin*, circa 1520-25, tin-glazed earthenware, H 9.2 cm, Diam 40.5 cm, 26.336. [Watson 32] (fig. 19)

13. Gubbio, *Plate with the Arms of the Saracinelli*, circa 1525-30, tin-glazed earthenware, H 4.3 cm, Diam 23.9 cm, 26.343. [Watson 36]

14. Urbino, Nicola da Urbino, *Plate with an Allegorical Scene of Calliope and a Youth*, from the Ladder Service, circa 1525-28, tin-glazed earthenware, H 4 cm, Diam 26.2 cm, 26.348. [Watson 45] (fig. 13)

15. Urbino, Francesco Xanto Avelli da Rovigo, *Plate with the Massacre of the Innocents*, circa 1527-30, tin-glazed earthenware, H. 5.5, Diam 48.7 cm, 26.350. [Watson 49] (fig. 7)

16. Urbino, Francesco Xanto Avelli da Rovigo, *Plate with the Battle of Roncevaux*, 1533, tin-glazed earthenware, H 4.5 cm, Diam 43.5 cm, 26.356. [Watson 53] (fig. 8)

17. Urbino, Fontana Workshop, *Pilgrim Flask with Myrrha and Adonis*, 1570-80, tin-glazed earthenware, Lid: H 8.2 cm, Diam 6 cm; Flask: H 48.9 cm, Diam 30 cm, 26.357. [Watson 62] (fig. 18)

18. Urbino, Francesco Xanto Avelli da Rovigo, *Plate with Pyramus and Thisbe*, 1536, tin-glazed earthenware, H 2.8 cm, Diam 26.3 cm, 26.360. [Watson 54]

19. Urbino, Francesco Xanto Avelli da Rovigo, *Plate with The Sinking of the Fleet of Seleucus*, from the Pucci Service, 1532, tin-glazed earthenware, H 2.3 cm, Diam 25.8 cm, 26.361. [Watson 52] (figs. 5 and 12)

20. Urbino, Painter of the Della Rovere Service, *Plate with Apollo and Marsyas*, 1541, tin-glazed earthenware, H 3.5 cm, Diam 26.5 cm, 26.364. [Watson 56]

21. Urbino, probably by Orazio Fontana, *Plate with St. Paul Preaching at Athens*, tin-glazed earthenware, H 7.2 cm, Diam 35 cm, 26.366. [Watson 48]

22. Urbino, *Plate with a Heraldic Design after Hans Sebald Lautensack*, circa 1552-63, tin-glazed earthenware, H 4.1 cm, Diam 24.1 cm, 26.370. [Watson 58] (fig. 15)

23. Urbino, Fontana Workshop, *Footed Dish with Galatea*, c. 1560-80, tin-glazed earthenware, H 12 cm, Diam 25 cm, 26.375. [Watson 61]

24. Urbino, Patanazzi Workshop, *Quadrilateral Flask with St. John the Baptist and Grotesques*, circa 1580-90, tin-glazed earthenware, H 24.5 cm, Base: 10.5 x 10.5 cm, 26.377. [Watson 63] (fig. 23)

25. Faenza, *Albarello with Turk's Head, Mascaroon, Rinceaux, and Trophies*, circa 1550-75, tin-glazed earthenware, H 28.4 cm, D 14.5 cm, 26.378. [Watson 75]

26. Deruta, *Dish with an Allegorical Scene*, circa 1520-25, tin-glazed earthenware, H 9.6 cm, Diam 41.4 cm, 26.380. [Watson 33] (fig. 20)

27. Castelli, Workshop of Orazio Pompeii, *Albarello with Bust of a Woman*, mid-sixteenth century, tin-glazed earthenware, H 21.2 cm, D 12.8 cm, 26.393. [Watson 84] (fig. 35)

28. Faenza, *Albarello with Putti*, c. 1500-10, tin-glazed earthenware, H 20 cm, Diam at mouth 10.5 cm, 26.400. [Watson 8]

29. Deruta, *Votive Plaque*, 1505, tin-glazed earthenware, H 2 cm, Diam 34.8 cm, 26.402. [Watson 27] (figs. 25a and 25b)

30. Faenza, *Albarello with Putti*, c. 1500-10, tin-glazed earthenware, H 20.5 cm, Diam 12.2 cm, 26.404. [Watson 9]

31. Faenza, *Inkstand with Sleeping Knight*, early sixteenth century, tin-glazed earthenware, H 13 cm, W 22 cm, D 16 cm, 26.415. [Watson 4] (fig. 24)

32. Deruta, *Albarello with Nymph and Satyr*, 1507, tin-glazed earthenware, H 23.3 cm, Diam 10.5, 26.419. [Watson 31] (fig. 31)

64

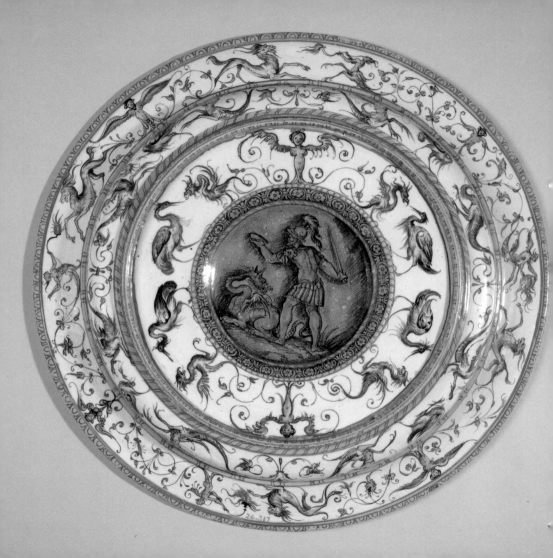